WHAT WE SEE IN THE STARS

AN
ILLUSTRATED TOUR
of the NIGHT SKY

WHAT WE SEE IN THE STARS

KELSEY OSEID

TEN SPEED PRESS
California | New York

CONTENTS

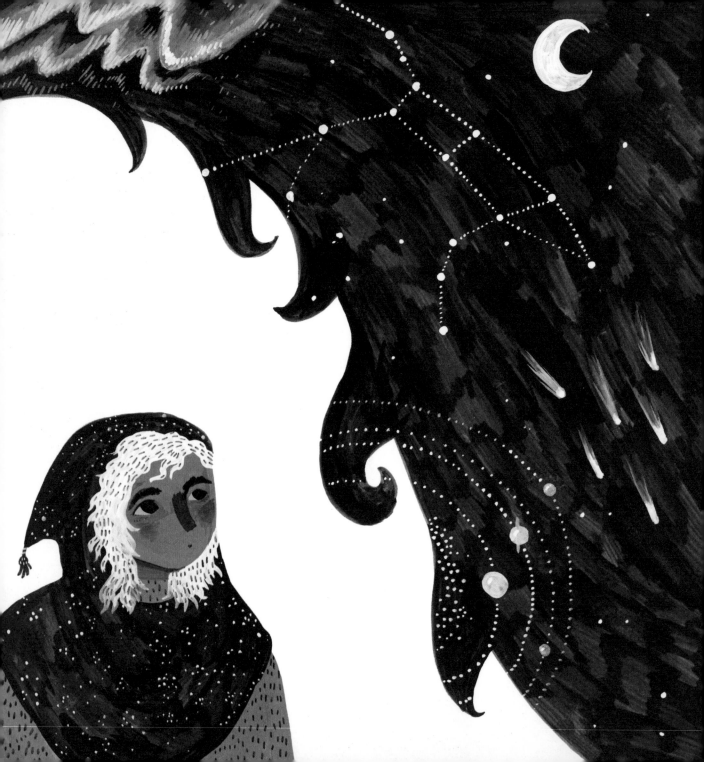

INTRODUCTION

For most of human history, our understanding of
the cosmos was based not on scientific evidence,
but on our direct observations of the night sky
as we gazed up at its sparkling, dark expanse.

We once imagined the sky to be something like
a hollow, spherical shell surrounding the Earth,
and stars as bright points on that shell. When
we began to notice that some of those bright
points took different paths across the sky than the
rest, we altered our explanation: the Earth was
encased not by one sphere, but by many perfectly
transparent crystal spheres nested inside one
another and spinning in different directions.
Onto these, we mapped constellations, the sun,
and the moon.

Our old theories about how the universe worked
were flawed, but stargazing was still key to some
of humanity's most important achievements.
Calendars based on the movement of the sun,
moon, and stars were important to the develop-
ment of early agriculture. Navigation based
on the positions of the constellations helped
explorers sail the globe. The importance of the
stars in our history is undeniable.

With so many of us spending a majority of our
time indoors and living in light-polluted cities,
our stargazing is often limited to occasionally
noticing the moon on a particularly luminous
night. Even the Milky Way—our own home galaxy
that appears as a soft stream of light stretching
across the sky—is impossible to see when drowned
out by the artificial light of our modern world.
We can forget the magic of the night sky.

To take a moment and gaze up is to connect to
an ancient human experience, and can be a great
source of wonder and awe. This book is a tour of
the night sky, centered on the old names and stories
still in use by astronomers today. It will cover the
most brilliant features of our solar system: the
constellations, the moon, the bright stars, and the
visible planets. And it will delve into less familiar
celestial phenomena too, like the outer planets
and deep space. Through it all, we'll explore some
of the ancient mythology behind our night sky,
as well as the basic science behind what we
see—and don't see—in the stars.

WHERE WE ARE
in SPACE

WHEN TALKING ABOUT THE
CELESTIAL PHENOMENA THAT
SURROUND US, SOME SCIENCE
EDUCATORS FIND IT HELPFUL
TO START WITH OUR
"COSMIC ADDRESS."

We live on a planet called
EARTH

orbiting a star called the
SUN

In a system called the
SOLAR SYSTEM

In a galaxy called the
MILKY WAY

In a group of galaxies called the
LOCAL GROUP

Which are part of the
VIRGO SUPERCLUSTER

Just one of the millions of superclusters in the
OBSERVABLE UNIVERSE

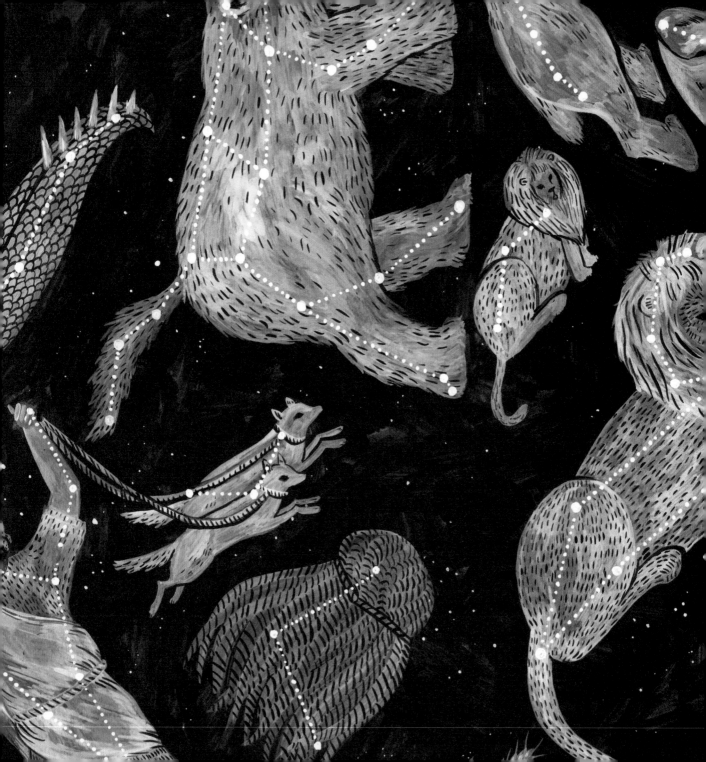

THE
CONSTELLATIONS

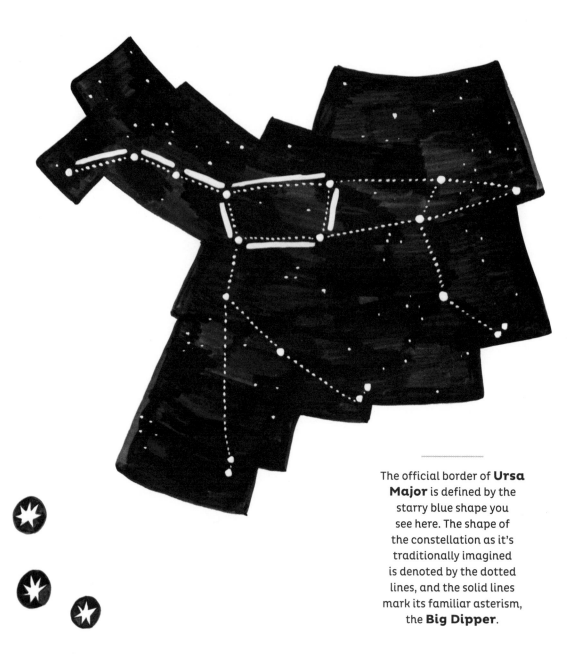

The official border of **Ursa Major** is defined by the starry blue shape you see here. The shape of the constellation as it's traditionally imagined is denoted by the dotted lines, and the solid lines mark its familiar asterism, the **Big Dipper**.

the CONSTELLATIONS

Constellations are at once something very old and something very young. We've given them ancient-sounding names—Aquila, Hydrus, Equuleus, Grus—based on words from now-dead languages. And we've ascribed ancient myths to them, full of gods, magic, adventure, and vengeance. What could feel older?

But the shapes in the sky are actually, in a sense, temporary. The fact that we see them at all is dependent on our perspective in time and space, because the universe is constantly shifting and changing. If we had popped into being at another time or place, the stars would look completely different to us. And while the stars that make up constellations appear close together, in most cases their actual positions in space aren't close at all. We might see them as flat, but the stars, of course, exist in three dimensions. If you could shift your point of view by traveling to a different star, you wouldn't recognize any familiar constellations.

It's hard to fathom the fact that these star shapes, which seem like such fixed parts of our world, are, on a cosmic time scale, fleeting.

We don't like to be reminded of our temporary nature, so we cling to the constants that seem surest. When we look up, we want to recognize what we see. And so far, we have been able to do just that.

The time scale of humanity is tiny in comparison to the scale of the universe—modern humans have existed for only about 200,000 years, while the universe is currently estimated to be 13.8 billion years old. The stars have been moving, but so slowly that to us they seem to have hardly moved at all. Our solar system has been moving slowly too. But still, as far back as we can remember, the constellations have looked the way they do today.

• • •

In astronomy, the term **constellation** actually refers to the area within a boundary drawn around that section of the sky, not the actual bright group of stars recognizable to the naked eye. Astronomers call those bright groups **asterisms**. Many—if not most—constellations contain asterisms of the same name (the constellation boundary of Orion contains one bright star shape: that of Orion the hunter). Other constellations contain recognizable asterisms within their boundaries (the constellation Ursa Major contains the asterism of the Big Dipper).

Though easily recognized asterisms like the Big Dipper can be helpful in orienting yourself as you look at the sky, in this book we will be focusing on the constellations defined by the **International Astronomical Union** (IAU). These are the boundaries astronomers use to describe where in the sky any particular phenomenon appears, and they encompass the entire sky.

· · ·

The constellations serve us as a sort of map legend; we have assigned every star that can be seen from Earth, whether visible to the naked eye or with a telescope, to a particular constellation. Other space phenomena are assigned to constellations as well—an astrophysicist might refer to a "nebula in the constellation of Taurus" or an "exoplanet in the constellation of Pegasus." Even though we can't see these deep-space objects with our naked eye, we can locate the boundaries of their constellations.

Throughout time, cultures all over the world have named and used countless constellations, many overlapping with one another. In 1930, in an effort to create a system that could be used internationally by amateur and professional astronomers, the IAU published a universal star map comprising eighty-eight constellations; this is the system astronomers use today.

More than half of the eighty-eight constellations come from the second century, when **Claudius Ptolemy**, a Greco-Egyptian philosopher and astronomer, published an authoritative work on the stars called the *Almagest*. He chose names for the constellations based on references from his culture, so they are rife with figures from ancient Greek mythology, as well as animals and objects common to the ancient Greeks (many of the names also have roots in Babylonian and Sumerian mythology). European astronomers added the remaining constellations in the sixteenth and seventeenth centuries. These additional constellations served to fill in the gaps in the star maps that weren't encompassed by Ptolemy's system, so that the entire sky could be divided into constellations. Many names of these more recent constellations reference new technologies of the time, as well as animals that European explorers were encountering for the first time as they sailed the globe to chart the southern skies.

Most ancients who studied the stars, including Ptolemy, believed in one variation or another of a **celestial sphere** theory: that the stars were just points of light embedded in a sphere surrounding the Earth, and that the Earth was the center of the cosmos.

In fact, belief in a celestial sphere was so strong that many old depictions of constellations were actually drawn as mirror images of the way we see them from Earth. This was meant to represent the way it was imagined the gods outside the sphere would see them.

the CELESTIAL SPHERE

Humans are famous for our pattern recognition skills—we see meaning everywhere, whether it's really there or not. Since ancient times, we've noticed groups of bright stars in the sky and categorized them into constellations, even when they bear hardly any similarity to the figures and objects they represent. Does the bright zigzag of Cassiopeia really look that much like a throne? How much do the stars that outline Orion's hourglass-shaped body really look like a torso? It's no more than coincidence that the stars are "arranged" in any particular way as viewed from the Earth, but our desire to find a pattern—a meaning—in the constellations is indicative of a phenomenon called **false pattern recognition**. Many examples of it can be found throughout the history of astronomy; we recognize ourselves and objects from our world in the stars because of false pattern recognition. And the things we see in the stars say a lot about us.

To this day, the constellations are still useful to us Earth dwellers. They're a way for us to understand an incredibly complex three-dimensional cosmos in two dimensions. By learning their names and a little bit about the stories connected to those names, we begin to build a vocabulary to understand and talk about the night sky.

BRIGHT STARS

The relative brightness or dimness of a star to a viewer on Earth depends on a number of factors. First, there is the star's proximity to Earth. Stars appear brighter if they're located closer to our solar system, and dimmer if they're farther away.

But not all the brightest stars in the sky are closest to us. Some stars are just bigger, and some are more intrinsically luminous. They may be farther from Earth than other stars, but we see them just as clearly, or more clearly. Sometimes we perceive bright spots in the sky as stars, but they're actually **star systems** made up of two or more stars—which also can increase the magnitude of their brightness as seen from Earth.

Though many old constellation names have their roots in Greek and Latin, most of the officially recognized names of the brightest stars have their roots in Arabic. Scholars from across the Islamic world were critical to the advancement of astronomy during medieval times. While much of western Europe was cloaked in the anti-intellectualism of their dark ages, Islamic scholars were in the midst of what is referred to as the Islamic Golden Age, which included astronomy. Astronomers like **Abd al-Rahman al-Sufi** created guides to the sky with Arabic names for the stars, often basing them on common star lore of the time. Those Arabic names have been translated (and sometimes Latinized) into the official names of those stars, many of which are still in use today.

PRECESSION & SHIFTING POLE STARS

If you live in the Northern Hemisphere, you've probably heard of the North Star, also called Polaris. It's not a particularly luminous star, but it's significant because of its position in the sky.

Located in the constellation of Ursa Minor, Polaris remains fixed overhead, while all the other visible stars appear to rotate around it. This makes it a helpful navigational tool, because no matter the time of night or time of year, it will point north—for at least another few hundred years or so, that is. While Polaris seems absolutely fixed in the sky, it won't always be the North Star because of a process called **precession**. The Earth spins on a north-south axis that's slightly tilted, which gives us different seasons at different times of the year as we orbit around the sun. But the tilt of Earth's axis goes through cycles, too. It slowly rotates at a rate imperceptible on the scale of a human lifetime, but which becomes obvious over hundreds and thousands of years. When the ancient Egyptians were building the pyramids, a star called **Thuban** in the constellation of Draco was the north polar star. There's even evidence that some of the pyramids were built to align with Thuban.

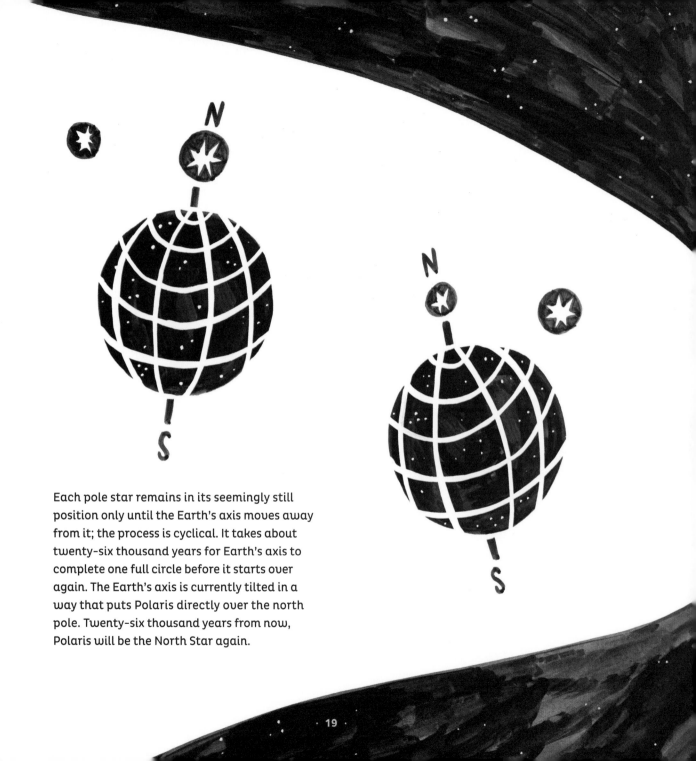

Each pole star remains in its seemingly still position only until the Earth's axis moves away from it; the process is cyclical. It takes about twenty-six thousand years for Earth's axis to complete one full circle before it starts over again. The Earth's axis is currently tilted in a way that puts Polaris directly over the north pole. Twenty-six thousand years from now, Polaris will be the North Star again.

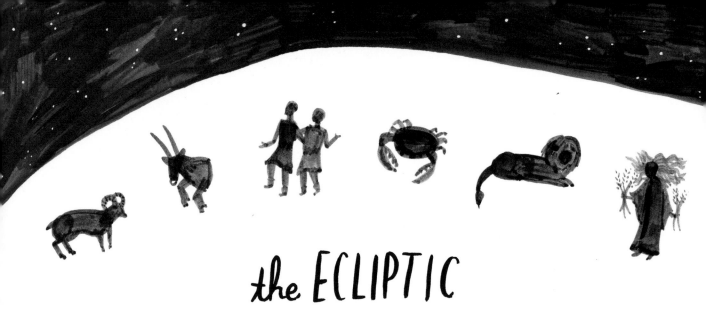

the ECLIPTIC

As the Earth makes its daily rotation, the objects in the night sky appear to rise and set, tracing a large arc across the sky as they go. The stars appear to travel more or less along the same path over the course of the night. But if you look carefully, you'll notice a few bright spots that look like stars but travel along a completely different path. These objects are the planets.

The word "planet" comes from an ancient Greek phrase meaning "wandering star," because to the ancients, the planets looked like stars that had decided not to follow the rest of the stars, but wandered their own path instead. That unique path drawn across the sky by the planets and the moon at night, and by the sun during the day, is called the **ecliptic.**

If you traced an imaginary line across that path on a star map, it would cross through thirteen constellations. These are Aries, Taurus, Gemini, Cancer, Leo, Virgo, Libra, Scorpio, Ophiuchus,

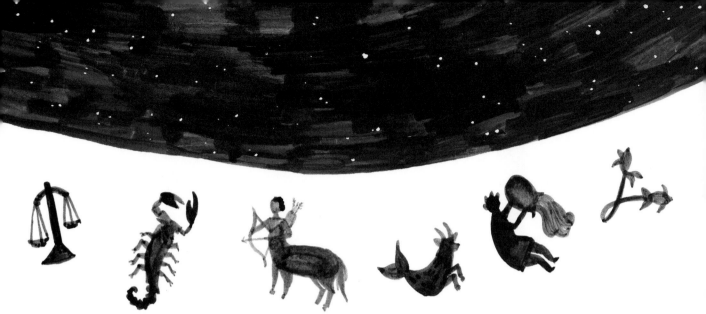

Sagittarius, Capricorn, Aquarius, and Pisces. All but Ophiuchus, which only barely touches the ecliptic, are familiar to many of us as the twelve signs of Western **astrology**, and are also known as the **constellations of the zodiac**.

Because of a phenomenon called **apparent retrograde motion,** planets sometimes appear to stop on their journey across the ecliptic, reverse direction and travel backwards for short periods of time, and then reverse again and continue in their original direction. Because ancient astronomers subscribed to a **geocentric** model of the universe—the idea that the Earth was at the center of everything—they viewed the cosmos as a kind of two-dimensional plane. Mathematicians and astronomers who believed in the geocentric model developed complicated and sometimes sophisticated equations to justify the motion of the planets in relation to the stars. They could work out the math, but they couldn't work out the physical reality of what was actually happening in the sky above their heads.

Today, we know that the sun—not the Earth—is at the center of our solar system. Modern astronomy can account for apparent retrograde motion because it views the cosmos in three dimensions. We now know that apparent retrograde motion is no more than a trick of perspective caused by the relative positions of the planets in their orbits.

PTOLEMY'S CONSTELLATIONS

Claudius Ptolemy was the ancient astronomer who named many of the constellations. Ptolemy lived in Alexandria, Egypt, during the second century and studied a variety of topics, including astronomy, math, geography, and even astrology. His *Almagest*, a comprehensive overview of his observations of the celestial sphere, included a catalogue of stars and their constellations.

As a Greco-Egyptian, Ptolemy's work was shaped by classical interpretations of the night sky, which is one reason so many constellations have Latin and Greek names. He was also influenced by an older history of astronomy that had its roots in ancient Mesopotamia, and his system of constellations combines those old Mesopotamian constellations, ancient Greek and Roman constellations, and a few newly categorized constellations. Often, constellations that had been depicted in a certain way since Babylonian times were ascribed names and stories from ancient Greek mythology, which were highly valued by Ptolemy and his contemporaries.

The *Almagest* was considered the authoritative work on constellations until the eighteenth century, when European astronomers began to add to (and sometimes alter), Ptolemy's star charts. Despite being tinkered with by countless astronomers during that time, Ptolemy's system survived mostly intact. Today, the forty-eight constellations he wrote about are in use as part of an internationally recognized official system of eighty-eight constellations.

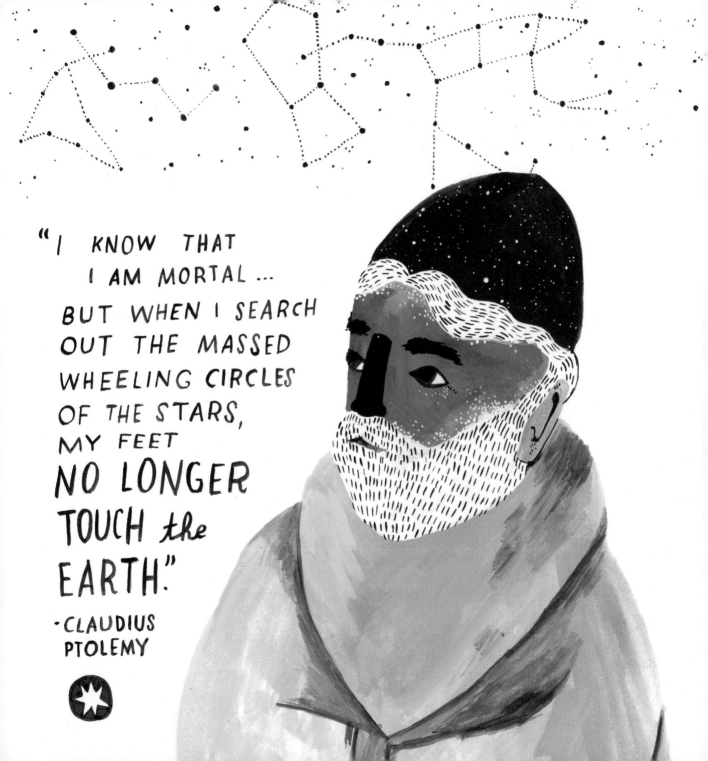

" I KNOW THAT
I AM MORTAL ...
BUT WHEN I SEARCH
OUT THE MASSED
WHEELING CIRCLES
OF THE STARS,
MY FEET
NO LONGER
TOUCH the
EARTH."
- CLAUDIUS
PTOLEMY

ANDROMEDA
the princess

The princess **Andromeda** appears in supporting roles in the stories of many of her neighboring constellations. She was boasted about by her mother, **Queen Cassiopeia**, in an incident that ultimately brought down the wrath of the gods. She was offered up as a sacrifice by her father, **King Cepheus**, and nearly eaten by **Cetus**, the sea monster. And she played damsel-in-distress to the hero **Perseus**, whom she later married. In illustrated star maps, she is often shown shackled by the chains her father used to secure her to the rock where she was to be sacrificed. And while she's often described as frail, Andromeda survived and went on to become a queen and the mother of nine children—maybe she wasn't so frail after all.

This constellation contains the **Andromeda Galaxy**, the nearest galaxy to our own. It's farther away from us than almost any other night-sky object visible without the aid of technology, and can be seen only under the best stargazing conditions. The Andromeda Galaxy is about twice as wide as our **Milky Way** galaxy, and science predicts that in the next few billion years the two will collide and spiral together into one super-galaxy.

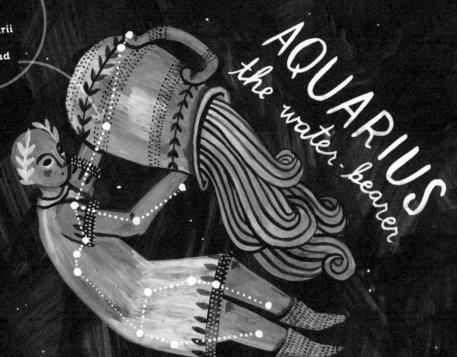

AQUARIUS
the water-bearer

Aquarius, one of the twelve constellations of the zodiac that lie along the **ecliptic**, is associated with the astrological sign of the same name. It's the tenth-largest constellation in the sky, but is made up of relatively dim stars. Depictions of Aquarius usually show him holding a vase or large jar, spilling water down onto the constellation **Piscis Austrinus**, the southern fish.

Aquarius is in the region of the sky known as "the sea," so-named because of the several water-themed constellations that reside there, including **Capricornus** the sea-goat, **Cetus** the sea monster, **Delphinus** the dolphin, and **Pisces** the fish. The name of its brightest star, **Sadalsuud**, comes from an Arabic phrase meaning "the luckiest of the lucky."

Alpha Aquilae
AKA
Altair

AQUILA *the eagle*

Eagles often appear in Greek mythology, so there are many Greek myths associated with this constellation. In one, Zeus's wife **Hera** transformed an unhappy widower into an eagle and placed him among the stars to help him forget his suffering. In another, Zeus transformed himself into an eagle in order to trick and kidnap **Ganymede** (who is also the namesake of one of **Jupiter**'s moons). And while Greek myths have been ascribed to **Aquila** since the time of Ptolemy, there are actually references to the constellation as an eagle in Babylonian star catalogues of centuries earlier. It's easy to see how this group of stars could be perceived as birdlike, and if any bird is worthy of a permanent place in the stars above, it would be the mighty eagle.

Aquila's brightest star, **Altair**, whose name comes from the Arabic for "eagle," is only seventeen light-years away from Earth, making it one of our closest bright stars.

ARA the altar

The altar is another common symbol in Greek mythology. In the story usually attributed to this constellation, the gods themselves gathered around an altar to swear their mutual loyalty as they set out to overthrow the **Titans**. After this gathering, **Zeus**, **Hestia**, **Demeter**, **Hera**, **Hades**, and **Poseidon** succeeded in conquering the Titans and taking over the universe. So from very early on, altars were important in any stories that involved the gods. Later, altars took a different role, as the sites of sacrifices to those same gods.

Ara is one of the smaller constellations, ranking sixty-third in size out of the eighty-eight. It lies along the **Milky Way**, so in some depictions, the galaxy's glow represents the smoke rising from an offering on the altar. The constellation contains the **red supergiant Westerlund 1-26**, one of the largest stars ever identified.

VELA the sails

CARINA the keel

PUPPIS the poop deck

BRIGHTEST STAR
Gamma Velorum

BRIGHTEST STAR
Zeta Puppis
AKA
Naos

BRIGHTEST STAR
Alpha Carinae
AKA
Canopus

ARGO NAVIS the ship Argo

Argo Navis is named for the **Argo**, the ship that **Jason and the Argonauts** sailed in ancient Greek myth. It's the only one of Ptolemy's constellations no longer in its original form. The total area it took up in the sky was large and unwieldy, so modern astronomers have divided it into three component constellations: **Carina** is the keel of the ship, **Puppis** is the ship's poop deck, and **Vela** is the ship's sails.

The name of Carina's brightest star, **Canopus**, is thought to come from the name of a sailor from a different Greek myth. The alternate name for Puppis's brightest star, **Naos**, comes from the ancient Greek for "ship." **Gamma Velorum**, the brightest star in Vela, doesn't have an official alternate name.

ARIES *the ram*

Aries is one of the twelve constellations of the zodiac, associated with the astrological sign of the same name. It is depicted in Ptolemy's system as a ram, and Ancient Egyptian astronomy associated it with a ram-headed god. Ptolemy was likely influenced by these depictions, but Aries has also been said to represent the ram with the golden fleece that **Jason and the Argonauts** quested for in Greek mythology.

The constellation Aries contains a number of distant galaxies, including some so close to one another that their gravitational fields have started to collide (similar to the way our **Milky Way** galaxy might one day collide with our neighboring galaxy **Andromeda**).

The alternate name of the constellation's brightest star, **Hamal**, comes from the Arabic for "the head of the ram."

AURIGA
the charioteer

The word **Auriga** is Latin for "chariot driver," and this constellation is usually depicted as either a charioteer or a pointed charioteer's helmet. In Babylonian astronomy, the constellation Auriga was depicted as a shepherd's crook; many depictions show the charioteer carrying a goat.

The alternate name for the constellation's brightest star, **Capella**, comes from the Latin for "female goat." While Capella looks like a single bright star—from Earth, it's one of the brightest objects in the night sky—it is actually a **star system** of two pairs of **binary stars**.

BOÖTES
the herdsman

Boötes, the herdsman, is recognizable by the kite-shaped **asterism** that makes up his body. His name comes from the ancient Greek for "herdsman," and he's often depicted with a staff or shepherd's crook in one hand and a scythe in the other. Sometimes he's also shown holding the neighboring dogs in the constellation **Canes Venatici** on a leash.

The brightest star in Boötes, **Arcturus**, is also one of the brightest stars in the night sky. The name *Arcturus* comes from the ancient Greek for "bear-watcher"—Boötes is located next to **Ursa Major**, and various descriptions speak of him guarding a herd from bears, hunting bears, or herding the bears themselves.

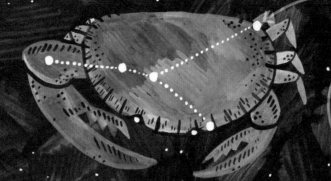

CANCER
the crab

Cancer is one of the twelve constellations of the zodiac, associated with the astrological sign of the same name. The word *cancer* comes from the Latin for "crab." The constellation is very dim compared to other star groupings—it's actually the dimmest of all the constellations of the zodiac. Ancient humans gave it a name and story anyway, probably to fill the gap along the **ecliptic** between its brighter neighbors, **Gemini** and **Leo**.

Cancer is home to one of the closest **open clusters** to our solar system: **Messier 44**, nicknamed the **Beehive Cluster**. This grouping of stars is visible as a nebulous blur with the naked eye, so even ancient astronomers could see it. In the seventeenth century, **Galileo Galilei** observed the Beehive with a telescope and was able to identify 40 individual stars within it. Today, we know that the Beehive contains over a thousand stars.

The name of Cancer's brightest star, **Altarf**, comes from the Arabic for "the edge."

BRIGHTEST
STAR

Alpha Canis Majoris
AKA
Sirius

CANIS MAJOR
the greater dog

Canis Major is positioned just southeast of the constellation **Orion** and appears to follow it as they travel across the sky, so the greater dog is often depicted as a hunting companion to Orion. It's also sometimes thought of as the mythological dog **Laelaps**, who had the ability to catch anything she chased.

Canis Major's brightest star, **Sirius**, is the brightest star in our night sky—it's almost twice as bright as the next-brightest star. Its name comes from the ancient Greek for "searing" or "glowing." In ancient times, it was an important star in navigation and calendar-making. It's actually a **binary star system** that our eyes perceive as one star. The star system is very luminous and relatively close to Earth, making it appear very bright. Sirius is also referred to as the "dog star," and the phrase *the dog days of summer* refers to the hottest days of summer when the sun and Sirius rise more or less at the same time.

CANIS MINOR *the lesser dog*

Like the neighboring **Canis Major**, the lesser dog is often depicted as one of **Orion**'s hunting dogs. It's also sometimes said to be the fox from the **Laelaps** myth: the dog Laelaps, represented in the sky by Canis Major, could catch anything, and the **Teumessian fox**, represented by **Canis Minor**, could never be caught. The dog began to pursue the fox, and a paradox was created. When **Zeus** noticed this, he put an end to it by placing both the creatures in the sky.

Also like Canis Major, Canis Minor contains a bright star: **Procyon** is the eighth-brightest star in our night sky. Unlike **Sirius**, though, Procyon isn't actually very luminous—it's just relatively close to our solar system, so it seems bright to us. The name *Procyon* comes from the ancient Greek for "before the dog," since it rises and sets just before the so-called "dog star" Sirius.

CAPRICORNUS
the sea-goat

Capricornus is one of the twelve constellations of the zodiac, associated with the astrological sign **Capricorn**. It is represented most often as a sea-goat, a **chimera** with the head of a goat and the body of a fish. The ancient Greeks associated it with **Pan**, the horned god of shepherds and flocks. But this constellation has its roots even earlier in ancient history, with the Sumerians, who called it the "goat-fish."

Capricornus is located in the region of the sky known as "the sea" for the many water-related constellations it contains, including Capricornus's bordering constellations **Aquarius**, the water-bearer, and **Piscis Austrinus**, the southern fish.

The name of its brightest star, **Deneb Algedi**, comes from the Arabic for "the goat's tail."

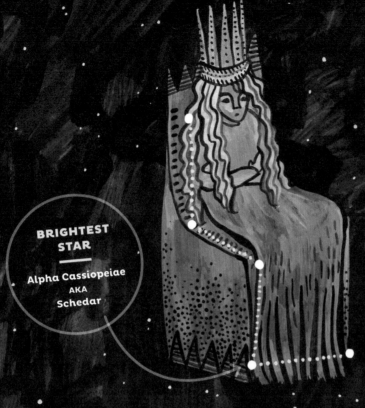

BRIGHTEST STAR
—
Alpha Cassiopeiae
AKA
Schedar

CASSIOPEIA *the queen*

Cassiopeia is one of the brightest and most recognizable constellations in the sky, appearing as a bright *W* or *M* depending on when it's observed. In Greek mythology, Cassiopeia was the queen ruling alongside **King Cepheus**. She's often called the "vain queen" because her story begins with her boasting about her beauty.

As the story goes, Cassiopeia claimed she and her daughter **Andromeda** were more beautiful than the sea nymphs. As vengeance, the sea-god

Poseidon sent a sea monster, **Cetus**, to destroy the queen's kingdom. Cassiopeia was then placed in the sky in such a position that she would be upside down half of the year, as a punishment. Now she rotates eternally around the sky, spending half her time upside down.

The name of Cassiopeia's brightest star, **Schedar**, comes from the Arabic for "chest," and in many depictions is located in the chest of the queen.

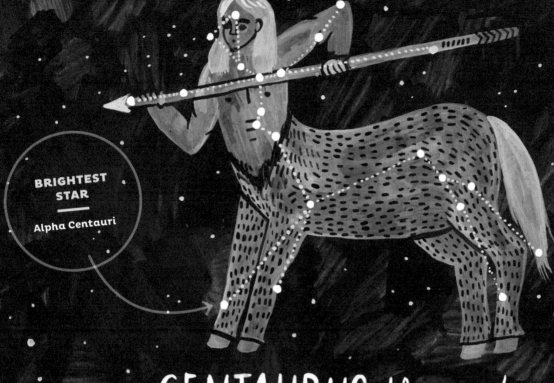

BRIGHTEST STAR

Alpha Centauri

CENTAURUS *the centaur*

Centaurs are creatures with the body of the horse and the torso and head of a man, an invention of Greek mythology. There are two centaurs in the sky: **Sagittarius**, the archer, and **Centaurus**. Centaurus is usually said to represent the wise centaur **Chiron**, teacher and trainer to many deities of Greek mythology.

Centaurus's brightest star, **Alpha Centauri**, is one of the brightest in the sky and is actually a system made up of two stars, **Alpha Centauri A** and **Alpha Centauri B**, along with a **red dwarf** called **Proxima Centauri**. The Alpha Centauri system is the closest **star system** to ours—Proxima Centauri, the closest component of that system, is only about four light-years away.

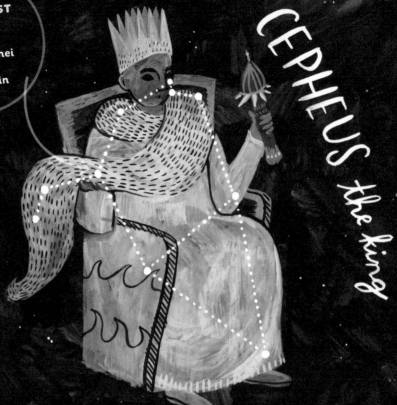

CEPHEUS the king

In Greek mythology, **Cepheus** was the husband of **Cassiopeia** and father of **Andromeda**. When Cassiopeia's boasts about her and their daughter's beauty incited the wrath of the sea-god **Poseidon**, Cepheus found his kingdom threatened and consulted an **oracle** on how to save it. The oracle told him to chain his daughter to a rock—and if **Perseus** hadn't swooped in at the last minute to save Andromeda, she would have been eaten by the sea monster **Cetus**. Even though some accounts describe Cepheus begging the gods to save Andromeda, all in all it's not the most flattering portrait of a king. Still, Cepheus somehow still managed to gain a permanent home among the stars.

The constellation Cepheus contains some of the largest known stars in the universe, as well as the most massive known **black hole**.

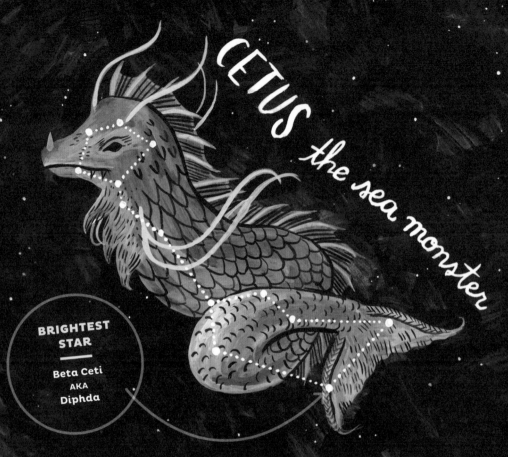

CETUS the sea monster

BRIGHTEST STAR

Beta Ceti
AKA
Diphda

Cetus is the fourth-largest constellation in the sky. Its name comes from the Latin for "large fish" or "sea monster." (**Cetacea** is also the scientific name for the clade of mammals that includes whales and dolphins.) In modern times, Cetus has been referred to as "the whale," but ancient depictions of this constellation usually referred to the sea monster from the myth of **Perseus** and **Andromeda**. It was sent to destroy **Cassiopeia**'s kingdom and nearly killed Andromeda before being thwarted by Perseus. Cetus is in a range of the night sky often referred to as "the sea" because of its many water-related constellations, such as **Aquarius** the water-bearer, **Delphinus** the dolphin, and **Eridanus** the river.

The name of its brightest star, **Diphda**, comes from the Arabic for "frog."

CORONA AUSTRALIS the southern crown

BRIGHTEST STAR

Alpha Coronae Australis AKA Alphekka Meridiana

Despite the fact that *corona* is Latin for "crowns," in old star charts **Corona Australis** is depicted as a wreath of leaves. Wreaths like this were sometimes given as awards to the winners of competitions in ancient Greece, and they appear throughout Greek mythology. Corona Australis is sometimes described as a wreath fallen from the head of **Sagittarius**, its neighboring constellation to the north.

It's one of the smallest constellations, ranking eightieth in size out of eighty-eight, and is often thought of as the southern counterpart to the other crown in the sky, **Corona Borealis** (*austral* comes from the Latin term for "southern").

Its brightest star, **Alphekka Meridiana**, is named after the brightest star in Corona Borealis.

CORONA BOREALIS
the northern crown

Ancient Greek mythology is full of kings and queens and royalty of all kinds. **Corona Borealis** is sometimes thought of as the crown that **Hephaestus**, the Greek god of metals and fire, made for the princess **Ariadne of Crete** to wear to her wedding to the god **Dionysus**. But Corona Borealis can really stand in for any one of the many crowns found in Greek mythology.

Its brightest star is named **Alphekka**, from the Arabic name for the constellation, meaning "broken up," a reference to the way the ring of stars appears to be broken at the top. The bright star is also sometimes called **Gemma**, from the Latin for "jewel" or "gem."

BRIGHTEST
STAR
—
Delta Crateris

CRATER the cup

Crater is a dim constellation in the southern sky; it represents the cup in the myth commonly associated with its neighboring constellations **Corvus**, the crow, and **Hydra**, the water snake.

Crater and Corvus are both associated with figures in a Greek myth about the god **Apollo**. In the myth, Apollo instructed a crow to bring him water from a spring. He gave the bird a cup, and sent him on his way. But the crow became distracted by a fig tree, and spent several days waiting for its fruit to ripen before finally filling the cup and returning to a frustrated Apollo.

The crow tried to blame his delay on the water snake that lived in the spring. Apollo didn't believe this story, and in a rage, flung the crow, the cup, and the snake into the sky where they became the constellations Corvus, Hydra, and Crater.

CORVUS the crow

Corvus, which borders **Crater**, is another dim and relatively small constellation. The primary myth associated with it is the **Apollo** story that's also ascribed to Crater. Along with the punishment Corvus received from Apollo in that story—imprisonment in the sky as a constellation—the crow is said to have received a number of other punishments at the hands of the gods, including being cursed with a spell that turned it its signature jet black color, and the placement of the cup of water, Crater, just out

Corvus's reach. In Greek myth, the dry "caw-caw" sound made by crows is a legacy of Corvus's perpetual thirst.

Corvus is also the scientific name for the genus of birds that includes crows and ravens.

The name of this constellation's brightest star, **Gienah**, comes from the Arabic for "the crow's right wing."

CYGNUS the swan

Cygnus is located along the **Milky Way** and is depicted as a swan. It is recognizable by the cross-shaped **asterism** that forms the body and main parts of the wings, referred to as the **Northern Cross**, which some stargazers also call the "backbone of the Milky Way."

The name Cygnus comes from the Greek word for "swan," and various Greek myths have been attributed to Cygnus, many of which entail people disguising themselves as swans or being transformed into swans by the gods.

The name of the brightest star in Cygnus, **Deneb**, comes from the Arabic word for "rear" or "tail," and in most depictions Deneb is located in the swan's tail. **Aquila**'s bright star **Altair**, **Lyra**'s bright stair **Vega**, and Deneb form the **Summer Triangle**, a prominent asterism that spans all three constellations and is visible in the Northern Hemisphere during the summer months.

DELPHINUS the dolphin

Dolphins were familiar animals in ancient Greece, where many people lived on the shore or worked on the water. The marine creatures symbolized helpfulness and generosity, and in mythology were frequently depicted performing selfless acts to rescue ailing humans, though some Greek myths also refer to gods using dolphins to persuade unsuspecting humans to do their bidding. Sometimes **Delphinus** is also described as the messenger of **Poseidon**, the Greek god of the sea.

The names of most constellations' brightest stars have their roots in ancient names and stories, but the name of Delphinus' brightest star, **Rotanev**, has a much more recent backstory. A nineteenth-century astronomer, **Niccolo Cacciatore**, named the star after himself, albeit in a surreptitious way. Cacciatore's Italian surname means "hunter," the Latin translation of which is *venator* (which, spelled backwards, is "Rotanev"). Rotanev is actually a **binary star system** composed of one giant and one subgiant star.

BRIGHTEST
STAR

Gamma Draconis
AKA
Eltanin

DRACO the dragon

The constellation **Draco** curls around the **North Star** and **Ursa Major**. It is often associated with the dragon of Greek mythology that **Hercules** killed during his mythical **twelve labors**. The name of its brightest star, **Eltanin**, comes from the Arabic for "the dragon" or "the serpent."

Draco's star **Thuban** used to be the northern **pole star**—it was the brightest star located almost directly above the north pole that appears stationary, due to its alignment with the Earth's axis. We know now that Earth's axis wobbles slowly over time and has shifted over the millennia. The current northern pole star is **Polaris** in **Ursa Minor**. The axis continues to wobble, though, and Thuban will become the northern pole star once again around twenty-thousand years from now.

EQUULEUS *the little horse*

The faint constellation **Equuleus** is the second-smallest constellation in the sky. Its name means "little horse" or "foal." It's thought that Ptolemy invented this constellation when he charted the sky for the *Almagest*, adding it to his catalogue of star shapes to fill in what he perceived as a void in his map of the stars. Because its roots aren't as ancient as those of other constellations, Equuleus is not really associated with any particular myth, though horses were certainly an important part of commerce and culture in Ptolemy's time.

Overshadowed in size and magnitude by the nearby constellation **Pegasus**, which has a large body and huge feathered wings, Equuleus is commonly depicted as a small horse's head, with its body usually missing from illustrated star maps. The name of its brightest star, **Kitalpha**, comes from the Arabic for "a piece of the horse."

ERIDANUS *the river*

Eridanus is the sixth-largest constellation in the sky. Its stars form a long and winding path, usually depicted as a river. Eridanus is sometimes thought of as one of the rivers of **Hades** from Greek mythology, and it's also associated with a number of real-life rivers, from the **Nile** in Egypt to a legendary river in Athens. Its roots as a constellation associated with water may go back as far as Babylonian times.

The constellation is thought to contain an **extremely** huge **supervoid**— a mysterious expanse of the universe mostly devoid of galaxies. Despite what their name might suggest, supervoids are not completely empty, but they are much less dense than the rest of the universe.

The name of Eridanus's brightest star, **Achernar**, comes from the Arabic for "the river's end."

GEMINI
the twins

Gemini is one of the twelve constellations of the zodiac, associated with the astrological sign of the same name. The word *gemini* is Latin for "twins." The mythological twins it is usually associated with are **Castor** and **Pollux**, which are also the names of the constellation's two brightest stars. In Greek mythology, Castor and Pollux were the twin sons of **Zeus**, and siblings to **Helen of Troy**. They are commonly depicted holding hands or with their arms around one another.

Gemini serves as a locator for the **Geminids**, a prominent meteor shower that occurs annually in December when the Earth passes through a trail of dust in the wake of an asteroid called **3200 Phaethon**. During a Geminids shower, it's sometimes possible to see as many as a hundred meteors in an hour.

HERCULES *the hero*

Hercules is the fifth-largest constellation in the sky, named for one of the most well-known characters of Greek mythology. He was one of many sons of **Zeus**, half-god and half-human. There are countless myths about his heroic exploits and journeys, including his **twelve labors**, which included many characters also represented in the sky. One of these is **Hydra**, the monstrous snake he killed in his second labor. Another is **Draco**, the dragon he killed in order to get to the golden apples in the **Garden of the Hesperides**.

The name of its brightest star, **Kornephoros**, comes from the ancient Greek for "club-bearer," and Hercules is usually depicted with a club in his hand.

HYDRA *the sea serpent*

Hydra is the largest constellation in our night sky. The sea serpent plays a supporting role in two other constellation stories. In the story of **Corvus** and **Crater**, in which the crow Corvus tried to deceive Apollo, Hydra is the snake that Corvus blames for his delayed delivery of a cup of water. In the story of the **twelve labors** of **Hercules**, Hydra is the poisonous many-headed monster slain by the hero as part of his second labor.

The name of its brightest star, **Alphard**, comes from the Arabic for "the lonely one" or "the individual," since there are no other particularly bright stars near it in the sky.

LEO the lion

Leo is one of the twelve constellations of the zodiac, associated with the astrological sign of the same name. It is connected with two mythological stories. In one, it is the **Nemean lion**, which **Hercules** hunted and skinned, thereafter wearing the skin. In the tragedy of **Pyramus** and **Thisbe**, Leo itself was the hunter, whose bloody jaws led Pyramus to mistakenly believe his lover Thisbe had been killed.

The constellation contains many bright stars and is a locator for the **Leonids**, one of the most abundant of our annual meteor showers. The name of the constellation's brightest star, **Regulus**, comes from the Latin for "the prince."

BRIGHTEST STAR

Alpha Leonis
AKA
Regulus

BRIGHTEST STAR

—

Alpha Leporis
AKA
Arneb

LEPUS *the hare*

Lepus, the hare, is a medium-sized constellation that appears near **Orion** in the sky. It is often depicted as being hunted by Orion and his dog, represented by **Canis Major**. It may have first been named for the hare in a Greek myth about the messenger of the god **Hermes**, who is said to have placed Lepus in the sky to commemorate the speed and agility of hares. Sometimes Lepus is also said to be fleeing from **Corvus**, the crow, since Lepus disappears below the horizon just as Corvus rises.

The constellation's brightest star is **Arneb**, named for the Arabic word for "hare." Arneb is in the last stages of its life and is expected to end in a **supernova**. Lepus is also home to a **globular cluster**—a massive, spherical collection of stars—called **Messier 79**.

LIBRA *the scales*

Libra is a faint, medium-sized constellation. It is one of the twelve constellations of the zodiac, associated with the astrological sign of the same name. Its name means "weighing scales," and it is usually depicted as a simple beam scale. Libra has alternately been depicted as the pincers of the scorpion **Scorpius**, and was sometimes called "the scorpion's claws" in ancient times. This constellation may have roots as far back as Babylonian times.

One of Libra's stars, a **red dwarf** star named **Gliese 581**, is thought to be the home star to a potentially habitable **exoplanet**. The name of the constellation's brightest star, **Zubeneschamali**, comes from the Arabic for "the northern claw," a reference to depictions of Libra as a part of Scorpius.

LUPUS *the wolf*

Lupus is a medium-sized constellation in the southern sky. The constellation is thought to have its earliest roots in Babylonian times, when it would have been associated with a strange carnivorous beast. The ancient Greeks saw it as an animal being hunted by—or sacrificed to—the nearby constellation **Centaurus** the centaur (sometimes Centaurus is depicted carrying Lupus impaled on a pole). Lupus wasn't specifically associated with wolves until a Renaissance Era translation of the *Almagest* was made; even so, today the constellation is virtually always depicted as a wolf.

Its brightest star, **Alpha Lupi**, is one of the closest stars to our solar system that is predicted to go **supernova**—it is in the final stages of its life, which will end in an explosion.

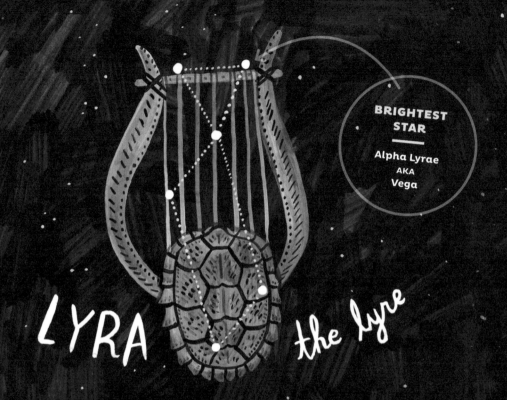

LYRA the lyre

A lyre is a stringed instrument that was popular in ancient Greece. **Lyra** is often depicted as the first lyre, built by the god **Hermes** out of an old tortoise shell. The name of its brightest star, **Vega**, is derived from the Arabic for "falling," from the phrase "the falling eagle," because in some ancient depictions, the stars that form Lyra represented a bird.

In addition to the bright star Vega (the fifth-brightest in the sky), Lyra also contains a "**double double**" star called **Epsilon Lyrae**. Seen with the naked eye, Epsilon Lyrae appears to be one star. But with binoculars, it becomes clear there are two components to Epsilon Lyrae that orbit one another. With additional magnification, another level of complexity emerges: each of Epsilon Lyrae's components can be further divided into pairs of **binary stars** that orbit each other. So in total, Epsilon Lyrae is composed of two sets of binary stars, with each pair of stars orbiting one another, and each set of stars orbiting the other.

OPHIUCHUS

the serpent-bearer

The name **Ophiuchus** comes from the ancient Greek for "serpent-bearer." He is usually depicted holding **Serpens**, the serpent, over his shoulders or wrapped around his body. In some depictions, Ophiuchus is meant to be fighting the serpent, and sometimes he's said to be learning healing secrets from it.

A small part of Ophiuchus does overlap with the **ecliptic**, so some astronomers consider it a thirteenth constellation of the zodiac. It is bordered on both sides by the two split halves of Serpens, which represents the serpent Ophiuchus holds.

The name of its brightest star, **Rasalhague**, comes from the Arabic for "the head of the serpent-bearer."

ORION
the hunter

Because of its size and relative brightness, **Orion** is one of the most easily identified constellations in the sky. It's named after a hunter from Greek mythology who was the son of **Poseidon**, the sea god. Orion's neighboring constellations, **Canis Major** and **Canis Minor**, are often depicted as his hunting companions. The trio are often depicted chasing after **Lepus**, the hare.

Just below **Orion's belt**, the three stars that define the waist of the hourglass-shape of Orion's body, is the **Orion Nebula**. One of the brightest nebulae in our sky, it is visible without the aid of a telescope, even in some of the most light-polluted settings. Also known as **Messier 42**, the Orion Nebula is one of the most-studied objects in the sky and has taught astronomers and astrophysicists a great deal about the way the universe works.

The name of Orion's brightest star, **Rigel**, comes from the Arabic for "the foot" or "the leg," referring to its placement in the constellation.

PEGASUS
the winged horse

A horse with enormous feathered wings, **Pegasus** was a mythical beast of Greek mythology. His mother was the snake-haired gorgon **Medusa** and his father was the sea-god **Poseidon**. In some stories, he carried the hero **Perseus** on his back. In others, he helps **Zeus** transport thunderbolts. This constellation is the seventh-largest in the sky, and is often depicted as just the head and front legs of a horse. Before the twentieth century standardization of constellation boundaries, some makers of star maps incorporated stars from smaller neighboring constellations to accommodate the imagined outlines of Pegasus's hind legs.

The name of its brightest star, **Enif**, comes from the Arabic for "nose," because in most depictions, Enif is positioned on the nose of Pegasus. Enif is in the last stages of its life as a star and is expected to die within the next few million years.

BRIGHTEST
STAR

Alpha Persei
AKA
Mirfak

PERSEUS *the hero*

Named after the same **Perseus** who saved **Andromeda** from the sea monster **Cetus**, this constellation is a locator for the **Perseids** meteor shower, one of the most active meteor showers in our sky. The Perseids appear each year when the Earth's orbit takes it through a path of space debris left by the comet **Swift-Tuttle**. Stargazers have witnessed hundreds of meteors in a matter of hours during this annual event.

Besides his rescue of Andromeda, Perseus is also famous for beheading the gorgon **Medusa** and being an ancestor of the hero **Hercules**.

The constellation's brightest star, **Mirfak**, gets its name from the Arabic for "elbow."

PISCES *the fishes*

Named with the Latin word for "fishes," **Pisces** is one of the twelve constellations of the zodiac, associated with the astrological sign of the same name. It is depicted as a pair of fishes, usually tied together with a length of cord. This depiction is based on a Greek myth about **Aphrodite**, the goddess of love, and her son **Eros**, the god of love, in which they transformed themselves into fish to escape from a monster.

Eta Piscium, the constellation's brightest star, was associated with water even in Babylonian times, when it was referred to as **Kullat Nunu**, the bucket of fish.

PISCIS AUSTRINUS
the southern fish

Piscis Austrinus is a relatively small constellation in contrast to the larger fish constellation, **Pisces**. In some stories, it is said to represent the parent of the two fish depicted in Pisces. Its name is Latin for "the southern fish," and it is sometimes also referred to as Piscis Australis. Though it's a relatively small constellation, older illustrations of Piscis Austrinus often depict it as a muscular, beast-like fish. It is often pictured with the water from **Aquarius**'s jar being poured onto its head or into its mouth. The constellation has its roots in the early star lore of the Babylonians, who first described it as a fish.

The name of its brightest star, **Fomalhaut**, comes from the Arabic for "the mouth of the fish" or "the mouth of the whale."

SAGITTA the arrow

Sagitta, the arrow, is one of the smallest constellations in the sky—the only smaller constellations are **Equuleus** and **Crux**. Despite being relatively dim, Sagitta has been a constellation since ancient times. Archery was a significant part of life across ancient cultures as a means of defense, in hunting, and as a recreational and competitive sport. Gods from many traditions, including Greek mythology, are described as archers.

Though the archer constellation, **Sagittarius**, holds a bow and arrow in many depictions, the arrow Sagitta is not generally seen as having been shot by Sagittarius—it's archer-less, and in star maps stands as a kind of icon all on its own.

Sagitta's brightest star is the **red giant Gamma Sagittae**. Another star in Sagitta, **Alpha Sagittae**, is also called Sham, for the Arabic word for "arrow."

SAGITTARIUS *the archer*

Sagittarius is one of the twelve constellations of the zodiac, associated with the astrological sign of the same name. It is depicted as a **centaur** using a bow and arrow. It also contains an **asterism**, the "**Teapot**." Since the constellation of Sagittarius overlaps with the **Milky Way**, the Teapot is sometimes depicted as pouring the Milky Way out of its spout.

Sagittarius contains many stars with known **exoplanets**. The name of its brightest star, **Kaus Australis**, comes from the Arabic for "bow" and the Latin for "southern," and in most depictions its location is on the outstretched bow.

SCORPIUS
the scorpion

Scorpius is one of the twelve constellations of the zodiac, associated with the astrological sign Scorpio. It is located next to the constellation **Libra**, and Libra is sometimes depicted as Scorpius's claws or pincers. It has its earliest roots in Babylonian star observation, but in Greek mythology, Scorpius represents the scorpion that fought and killed **Orion** the hunter.

Scorpius lies along the **Milky Way** and so contains many interesting star clusters, including **Messier 7**, also known as the **Ptolemy Cluster**, an open star cluster named after Claudius Ptolemy himself.

The name of its brightest star, **Antares**, comes from an ancient Greek phrase meaning "like Mars." This is because Antares is a **red supergiant** that actually appears slightly reddish even to the naked eye, which is reminiscent of the red planet **Mars**, which gets its rusty color from oxidized iron on its surface.

SERPENS *the serpent*

Serpens is the only constellation to be divided into two parts. **Serpens Caput**, the serpent's head, lies to the east of **Ophiuchus**, the serpent-bearer, while **Serpens Cauda**, its tail, lies to the west. Ophiuchus is usually depicted with Serpens curled around his body or in his arms. Serpens contains the **Red Square Nebula**, a **bipolar nebula** with four sharp corners and straight sides, which is said to be one of the most symmetrical deep space objects ever observed.

The name of the constellation's brightest star, **Unukalhai**, comes from the Arabic for "serpent's neck."

TAURUS *the bull*

Taurus is one of the twelve constellations of the zodiac, associated with the astrological sign of the same name. Star maps have traditionally shown Taurus head-on, with only his front legs, chest, and head visible. Taurus is home to two prominent **star clusters**: the **Pleiades** and the **Hyades**.

The Pleiades, also called the **Seven Sisters**, form the star cluster most visible to the naked eye. These seven stars were once considered a constellation. The Hyades were five daughters of **Atlas**—the Titan of ancient Greek myth who carried the world on his shoulders—and half-sisters to the Pleiades, also daughters of Atlas.

Star clusters were sometimes used as eye tests in ancient times—if you could see all seven stars of the Pleaides (which are not all easily visible to someone with average eyesight), you were thought to have excellent vision.

The name of Taurus's brightest star, **Aldebaran**, comes from the Arabic word for "to follow," because Aldebaran rises and sets after the Pleiades, following them across the sky.

TRIANGULUM
the triangle

Triangulum, named for the triangle formed by its three brightest stars, is one of the smallest constellations. The ancient Greeks sometimes called Triangulum "Deltoton" after the triangle-shaped Greek letter delta. It's one of two "triangle" constellations in the sky, the other being the modern constellation **Triangulum Australe**, which was first added to star maps in the late sixteenth century. **Johannes Hevelius**, a seventeenth century astronomer who named several of the modern constellations in use today, tried to add his own triangle constellation, "Triangulum Minus," to star maps, but it was removed by later mapmakers.

Triangulum contains the first **quasar** ever discovered. It's also home to the Triangulum galaxy, one of our galactic neighbors in the Local Group of galaxies. Its brightest star is **Beta Trianguli**, and another of its stars, **Alpha Trianguli**, was traditionally called **Mothallah**, from an Arabic phrase meaning "triangle."

URSA MAJOR *the great bear*

Ursa Major, Latin for "great bear," is the third-largest constellation in the sky, and also one of the brightest. It is commonly recognized by its prominent **asterism**, the **Big Dipper**, and is visible nearly year-round in the Northern Hemisphere. The great bear has a long tail traced by some of the constellation's brightest stars—which is somewhat odd, since no bears on Earth have such long tails. Despite that anomaly, Ursa Major has been identified as a bear by many cultures and civilizations for thousands of years. Some historians believe that stories told about the constellation may even have roots as far back as the Paleolithic period.

Two bright stars of Ursa Major, **Dubhe** and **Merak**, which form the front edge of the cup of the Big Dipper, can be used to locate **Polaris**, the **North Star**.

BRIGHTEST
STAR

Alpha Ursae Minoris
AKA
Polaris

URSA MINOR *the lesser bear*

Ursa Minor is the "little bear" or the **Little Dipper**. It looks like a miniature version of the **Big Dipper**, the **asterism** found in nearby **Ursa Major**. And it's home to **Polaris**, the current north polar star. The name *Polaris* comes from the Latin for "near the pole," and because of its navigational usefulness as a fixed northern point in the sky, Polaris has common names in many cultures around the world, often in reference to its apparently stable position—

"the axle," "the **North Star**," and "the guiding star" are just a few. Because of **precession**, polar stars change over time. Polaris hasn't always been the North Star. And even though it's the guiding star now, in a few centuries, precession will have altered our view of the night sky significantly. It's predicted that by the year 3000, the north polar star will be **Gamma Cephei** in the constellation **Cepheus**.

VIRGO
the virgin

Virgo is one of the twelve constellations of the zodiac, associated with the astrological sign of the same name. It's the second-largest constellation in the sky, surpassed in size only by **Hydra**, and its name is Latin for "virgin." Virgo is typically depicted as the Greek goddess of agriculture and fertility, **Demeter**.

Virgo contains the **Virgo Cluster**, a cluster of gravitationally bound galaxies. And it's also the namesake of the **Virgo Supercluster**, the supercluster of galaxies that our own **Milky Way** belongs to.

On star maps, Virgo is often shown with a stalk of wheat or grass in her arms, and the name of the constellation's brightest star, **Spica**, is Latin for "ear" (like an ear of corn). Spica is actually a **binary star system**, but its two component stars orbit each other so closely that they are difficult to resolve as separate stars even with the use of a telescope.

the MODERN CONSTELLATIONS

Ptolemy's system of constellations worked for a long time. It encompassed most of the sky's brightest stars and was widely recognized by the Western world for many centuries. But when Western explorers began to travel to the Southern Hemisphere for the first time, charting the skies with the aid of telescopes, it became clear that the Ptolemy's system wasn't comprehensive enough for modern astronomy—it had left too many gaps in the sky.

Explorers and astronomers made new maps of the skies, adding new constellations wherever they saw fit. Eventually, constellation-making got out of hand. Too many different star maps contained conflicting information and were confusing to use. Astronomy needed one official map of the sky to govern astronomers' observations and help stargazers, professional and amateur, around the world communicate effectively about their observations of the sky.

To meet this need, in 1930, a group called the International Astronomical Union created their official map of the sky. They used all forty-eight of Ptolemy's constellations. They divided up one of them, **Argo Navis**, into three component constellations—**Vela**, **Puppis**, and **Carina**—to ensure that no single constellation took up too much of the sky. Then, to encompass all the areas of the sky not covered by Ptolemy's constellations, the **IAU** added another thirty-eight selected constellations from maps by astronomers and navigators **Petrus Plancius**, **Johannes Hevelius**, **Abbe Nicolas-Louis de Lacaille**, **Pieter Dirkszoon Keyser**, and **Frederick de Houtman**. The IAU drew set boundaries around each constellation, and the map based on these became the official constellation system still in use today.

The thirty-eight newly added constellations take their names from prominent explorers' interests, ranging from scientific instruments, to animals, to geographical features—and even one historical figure.

TOOLS, ART & TECHNOLOGY

Abbe Nicolas-Louis de Lacaille, an eighteenth-century
French astronomer, liked to name constellations
after tools, art, and technology—especially those that
were new and exciting during the Enlightenment.
Thirteen of these constellations are still in use
in the modern system:

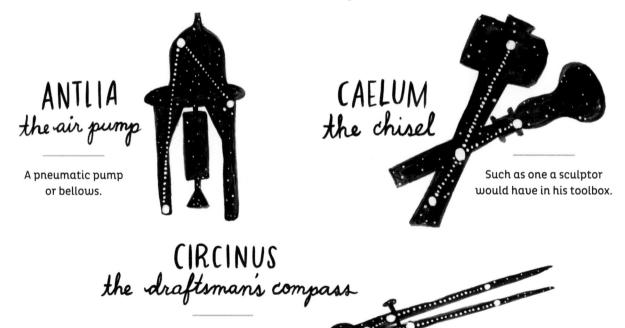

ANTLIA
the air pump

A pneumatic pump
or bellows.

CAELUM
the chisel

Such as one a sculptor
would have in his toolbox.

CIRCINUS
the draftsman's compass

The drawing tool used to
create circles and arcs.

FORNAX
the furnace

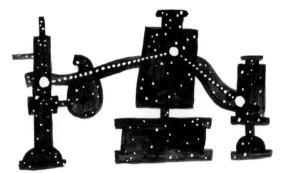

Specifically, a type of chemist's furnace used in scientific experiments.

HOROLOGIUM
the clock

A pendulum clock.

MICROSCOPIUM
the microscope

The scientific instrument used to magnify and examine things too small to see with the naked eye.

NORMA
the square

The right-angle tool used in drafting and carpentry.

OCTANS
the octant

The navigational tool
used to measure angles
between objects.

PICTOR
the painter

Usually depicted
as an easel.

PYXIS
the mariner's compass

A critical tool for
anyone navigating the seas
to chart the skies.

RETICULUM
the net

The grid of
fine lines in the eyepiece
of a telescope, sometimes
called a net.

SCULPTOR
the sculptor

Usually depicted
as a sculptor's work
table or studio.

TELESCOPIUM
the telescope

The scientific
instrument used to
magnify and examine
very distant objects.

SEXTANS
the sextant

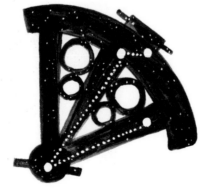

Johannes Hevelius named
a constellation after
a piece of technology, too.
Sextans, the sextant, is
named after a navigational
tool—related to the octant—
that Hevelius himself would
have used to measure
distances between objects
in the sky.

ANIMALS & MYTHICAL CREATURES

Eighteen modern constellations take their names from animals and mythical creatures. As explorers traveled the world and charted new parts of the sky, they encountered an abundance of wildlife unfamiliar to them, which inspired the names of these constellations.

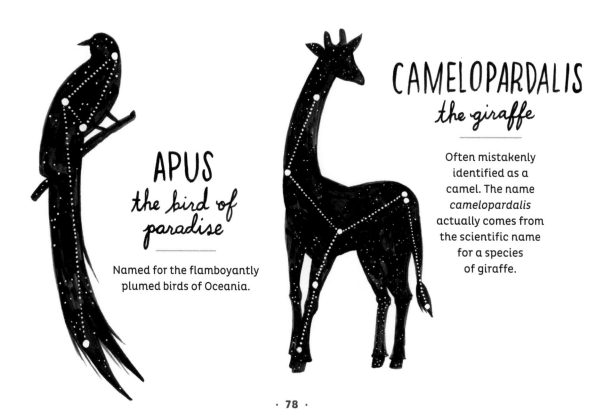

APUS
the bird of paradise

Named for the flamboyantly plumed birds of Oceania.

CAMELOPARDALIS
the giraffe

Often mistakenly identified as a camel. The name *camelopardalis* actually comes from the scientific name for a species of giraffe.

CANES VENATICI
the hunting dogs

Usually shown held on a leash by the nearby constellation Boötes.

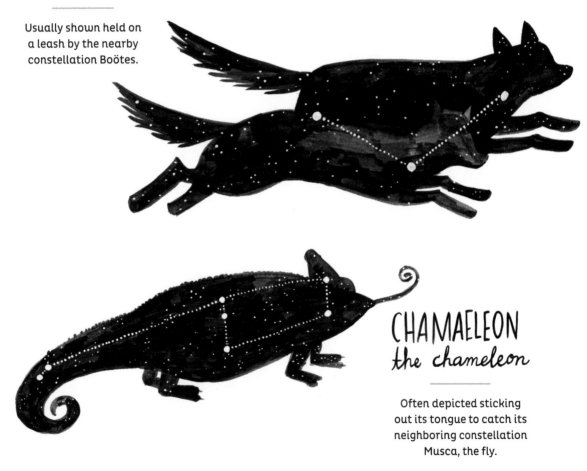

CHAMAELEON
the chameleon

Often depicted sticking out its tongue to catch its neighboring constellation Musca, the fly.

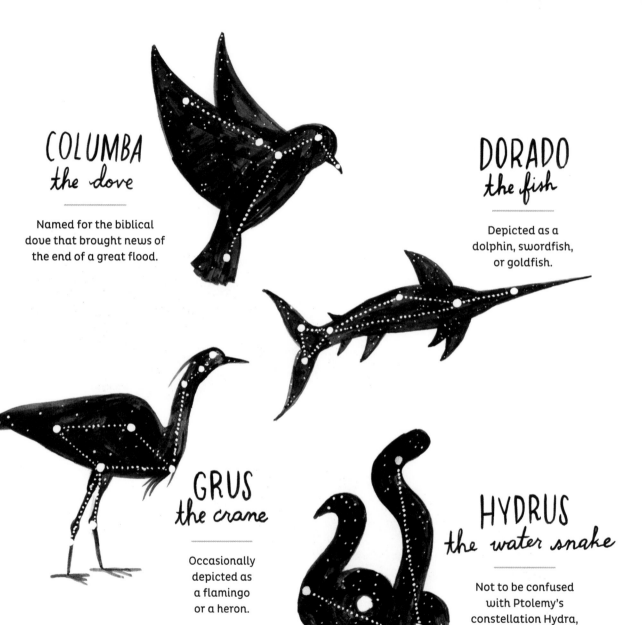

COLUMBA
the dove

Named for the biblical dove that brought news of the end of a great flood.

DORADO
the fish

Depicted as a dolphin, swordfish, or goldfish.

GRUS
the crane

Occasionally depicted as a flamingo or a heron.

HYDRUS
the water snake

Not to be confused with Ptolemy's constellation Hydra, the sea snake.

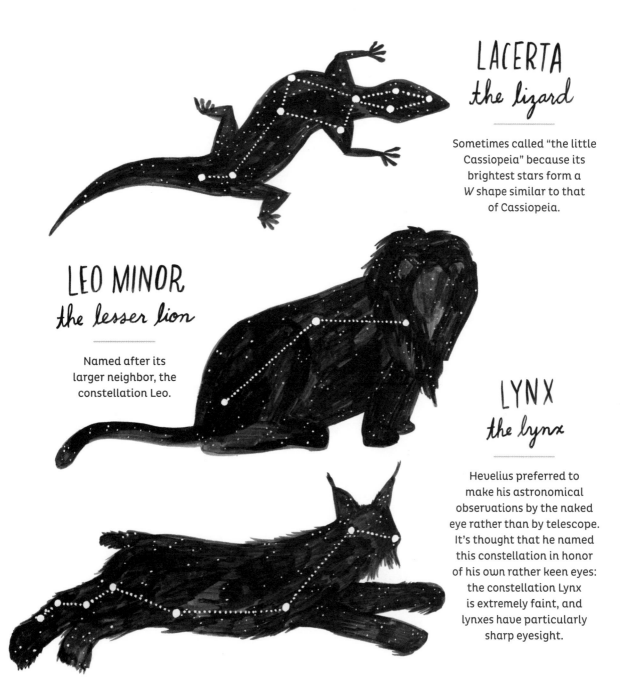

LACERTA
the lizard

Sometimes called "the little Cassiopeia" because its brightest stars form a *W* shape similar to that of Cassiopeia.

LEO MINOR
the lesser lion

Named after its larger neighbor, the constellation Leo.

LYNX
the lynx

Hevelius preferred to make his astronomical observations by the naked eye rather than by telescope. It's thought that he named this constellation in honor of his own rather keen eyes: the constellation Lynx is extremely faint, and lynxes have particularly sharp eyesight.

MONOCEROS
the unicorn

Named for the
mythical unicorn,
a horse with a single
horn in the middle
of its forehead.

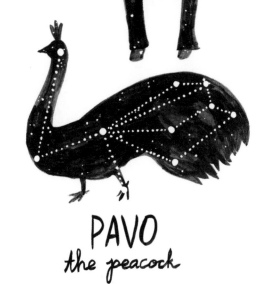

MUSCA
the southern fly

Usually shown being eaten
by its neighboring
constellation Chamaeleon.

PAVO
the peacock

Named for the beautiful green
peafowl of Southeast Asia.

PHOENIX
the phoenix

Named for the mythical bird that lived for centuries and could be reborn from its own ashes after its death.

TUCANA
the toucan

Named for the colorful, large-billed tropical bird.

VOLANS
the flying fish

Named for the real-life fish species with wing-like fins and the ability to leap out of the water and soar through the air.

VULPECULA
the little fox

Sometimes shown carrying a dead goose in its mouth.

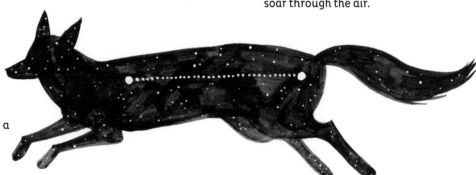

OTHER MODERN CONSTELLATIONS

The remaining constellations are named for people, places, abstract shapes, and more.

COMA BERENICES
Berenice's hair

The spray of stars that makes up Coma Berenices was observed in ancient times, and Ptolemy even referred to it as the tuft of hair on the end of Leo's tail. It's the only constellation to be named after a real person: Berenice II, an Egyptian queen who cut off her long hair and left it in a temple as an offering to the gods. When the hair disappeared a few days later, people said that it had been turned into stars and placed in the sky to commemorate the queen's act of devotion.

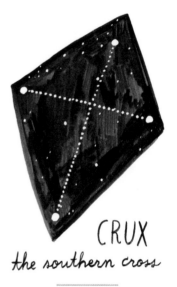

CRUX
the southern cross

The Southern Cross's four main stars are very bright, so this constellation is easy to spot from the Southern Hemisphere. The ancient Greeks had seen and documented the Southern Cross, but usually thought of it as part of the constellation Centaurus.

INDUS *the Indian*

A politically incorrect
constellation name, chosen
hundreds of years ago.
If any constellation is
due for a renaming,
it's this one.

MENSA
the table

Mensa is named after
Table Mountain, a
flat-topped mountain
near Lacaille's observatory
on the Cape of Good Hope
in South Africa.

SCUTUM
the shield

Named by Hevelius, and
originally ascribed to a
specific battle, but now
depicted as a generic shield.

TRIANGULUM AUSTRALE
the southern triangle

Not to be confused
with Triangulum, another
small constellation to the
north, this constellation
ranks eighty-third in size
among the eighty-eight
constellations.

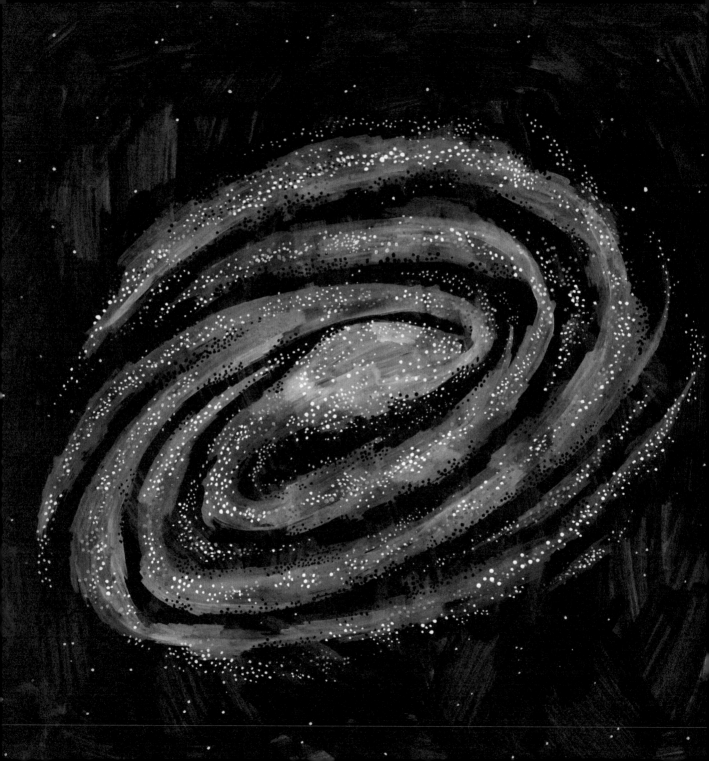

THE MILKY WAY

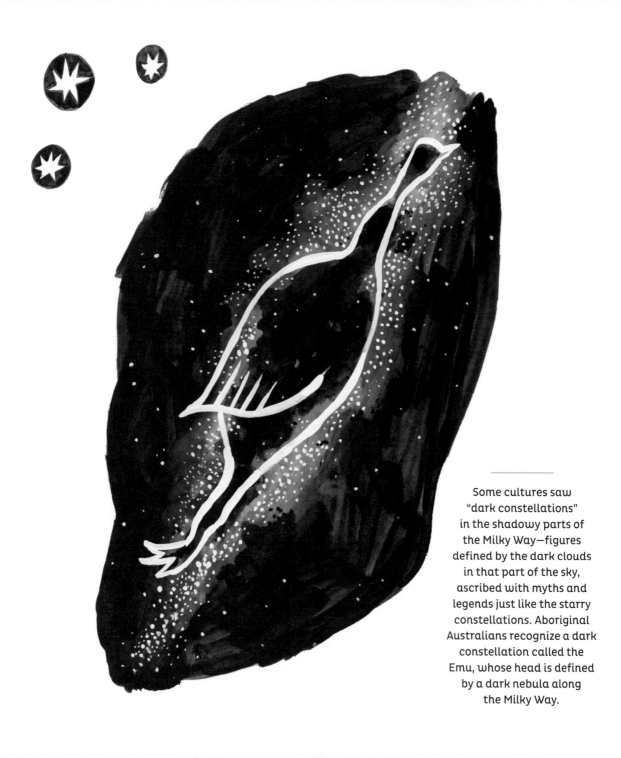

Some cultures saw
"dark constellations"
in the shadowy parts of
the Milky Way—figures
defined by the dark clouds
in that part of the sky,
ascribed with myths and
legends just like the starry
constellations. Aboriginal
Australians recognize a dark
constellation called the
Emu, whose head is defined
by a dark nebula along
the Milky Way.

✪ the MILKY WAY ✪

A wide swath of dimly glowing light reaching across our sky, the **Milky Way** is the galaxy to which our solar system belongs. It has been given many names through the ages and played a role in many myths. Some of these are still told, some are remembered only as ancient lore, and others have passed into forgotten history.

The name *Milky Way* is a translation of the Latin *Via Lactea*. Ancient Greeks called the Milky Way *galaxias*, meaning "milky"—that's where the word *galaxy* comes from.

Most galaxies fall into one of three shape categories: spiral, elliptical, or irregular. The Milky Way is a spiral-shaped galaxy, about a hundred thousand light-years across. It contains one hundred billion stars or more, according to current estimates. Our sun is located near the galaxy's edge, away from the center. Because we see it from our position within the spiral, the rest of the galaxy appears to us as a band of stars and light in our night sky.

SPIRAL

ELLIPTICAL

IRREGULAR

The Milky Way is most visible when light pollution is at a minimum. Since light pollution is mostly a modern phenomenon (a full moon creates some light pollution, but the primary culprit is excessive artificial light), ancient cultures generally had a much better view of the Milky Way. Virtually every culture has had a name and a story associated with it—here are the names of just a few.

THE GREAT FENCE OF THE

THE WAY THE DOG RAN AWAY

THE SILVER RIVER

THE WAY OF THE

THE STRAW THIEF'S WAY

ROAD TO THE PALACE OF HEAVEN

GOD'S

THE WAY OF BIRDS

THE HEAVENLY SEAM

STARS

THE WAY OF THE WHITE ELEPHANT

THE CELESTIAL RIVER

GRAY GOOSE THE RIVER OF HEAVEN

THE RIVER OF LIGHT

THE WINTER WAY

FOOTPRINTS

THE DEER JUMP

THE ROUTE OF SCATTERED STRAW

THE SHADOW WAY

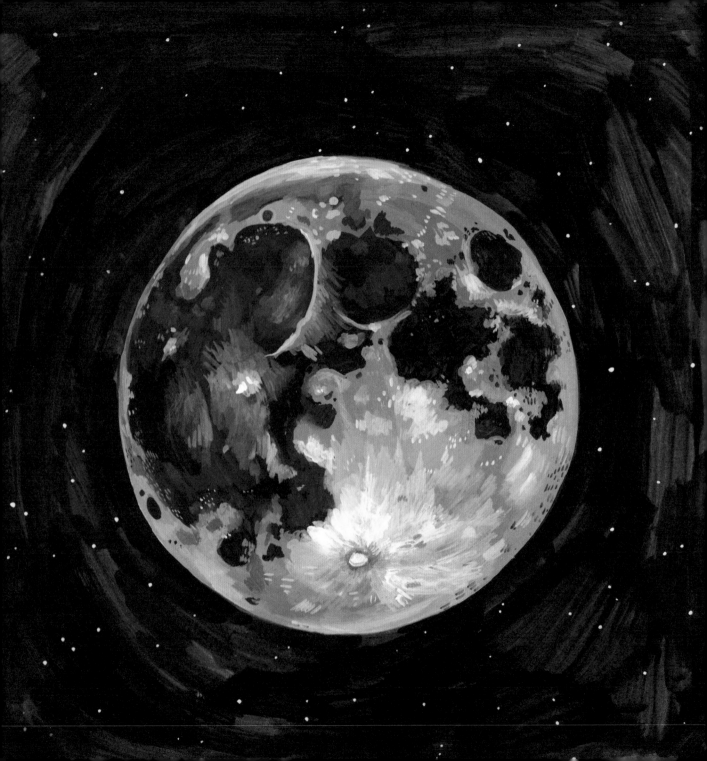

THE
MOON

the PHASES of the MOON

At any given time, half of Earth's turning sphere is illuminated by the sun while the other is in darkness. This is what gives us day and night. Half of the sphere of the moon is always illuminated by the sun, too. As the moon orbits the Earth over the course of a month, the portion of the illuminated side that we can see from Earth changes. We call the varying views of that illuminated portion the **phases** of the moon.

When the moon appears to grow, we say it is **waxing**. When it appears to shrink, we say it is **waning**. A completely illuminated view of the moon from the Earth is called a **full moon**, and completely dark view of the moon from the Earth is called a **new moon**.

Other objects orbiting our sun go through the same phases the moon does. For example, from a vantage point on the moon, the

Earth goes through the various phases in reverse. And with magnification, it's possible to see Venus and Mercury, whose orbits lie between Earth and the sun, go through the phases, too.

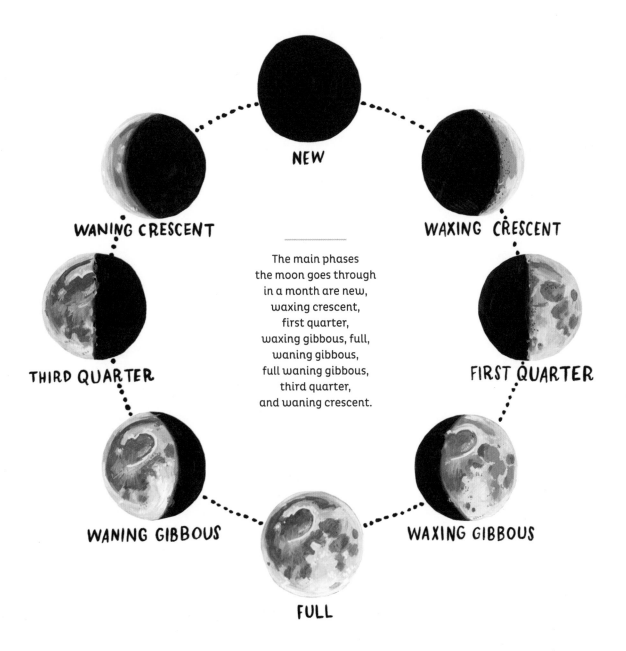

NEW

WAXING CRESCENT

WANING CRESCENT

The main phases
the moon goes through
in a month are new,
waxing crescent,
first quarter,
waxing gibbous, full,
waning gibbous,
full waning gibbous,
third quarter,
and waning crescent.

FIRST QUARTER

THIRD QUARTER

WANING GIBBOUS

WAXING GIBBOUS

FULL

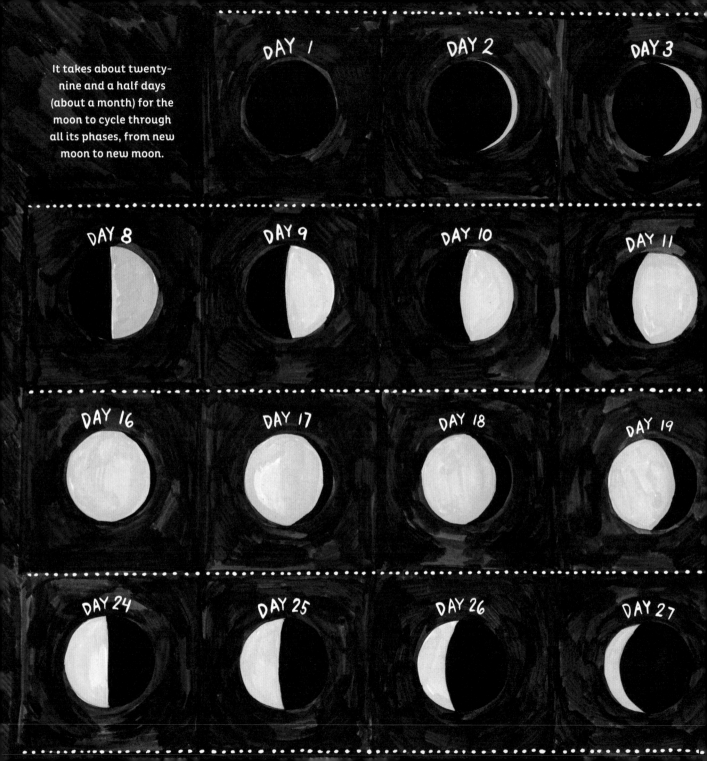

It takes about twenty-nine and a half days (about a month) for the moon to cycle through all its phases, from new moon to new moon.

DAY 1

DAY 2

DAY 3

DAY 8

DAY 9

DAY 10

DAY 11

DAY 16

DAY 17

DAY 18

DAY 19

DAY 24

DAY 25

DAY 26

DAY 27

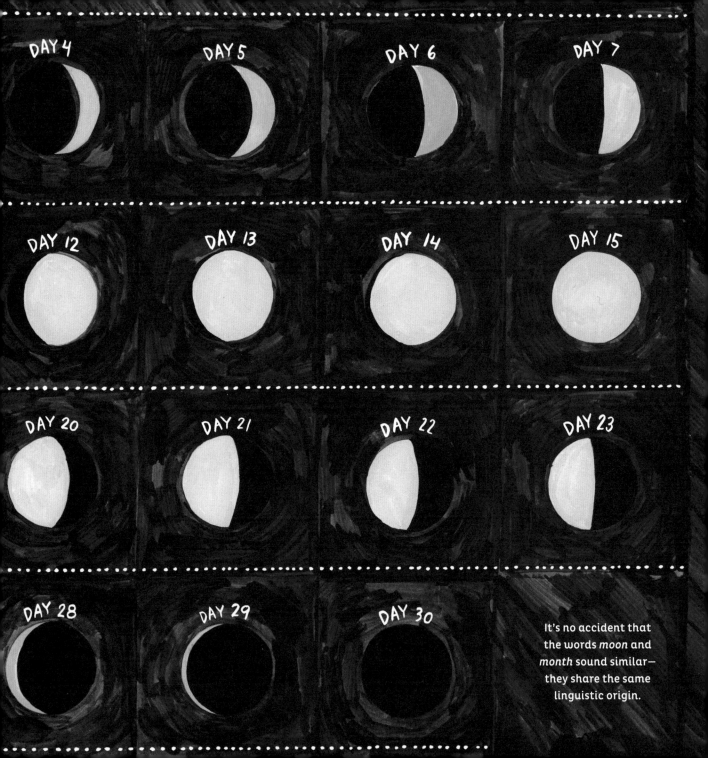

DAY 4

DAY 5

DAY 6

DAY 7

DAY 12

DAY 13

DAY 14

DAY 15

DAY 20

DAY 21

DAY 22

DAY 23

DAY 28

DAY 29

DAY 30

It's no accident that the words *moon* and *month* sound similar— they share the same linguistic origin.

 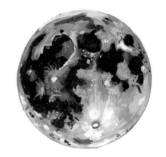

DISK SIZES

The term **disk size** refers to the apparent size of an astronomical object viewed from Earth. The moon's diameter is about 3,474 km (2,159 miles), and the sun's diameter is about 1.3914 million km (864,576 miles)— around four hundred times that of the moon.

Because the sun also happens to be around four hundred times farther away from Earth than the moon is, the disk sizes of the sun and moon are nearly identical in our sky. And throughout history, they have often been given equal importance in many models of understanding the night sky. When most people still believed the Earth was the center of the universe, there was no reason to believe the sun and the moon were different distances from the Earth. If they were both the same

distance from us, and appeared to be the same size in the sky, it was assumed that they must be the same size close up as well.

In reality, of course, the sun is enormous in comparison to the moon. And its impact on the Earth is likewise enormous: it's the primary source of the energy on our planet, and without it, life could never have evolved. But the other orb in our sky—our moon—still exerts important influence over life on Earth.

TIDAL LOCKING

You may know that the moon causes tides—the rising and falling of surface levels in large bodies of water. This happens because the moon and the Earth are **tidally locked**.

This means that the moon's **orbital period**—the time it takes to make one full orbit around the Earth—and its **rotational period**—the time it takes to make one full rotation on its axis—are the same, around 27 days. The moon wasn't always tidally locked to the Earth—the effect happened slowly over time. Most other large moons in our solar system experience a similar effect in relation to the bodies they orbit. Some even experience **mutual tidal locking**. Pluto, for example, is mutually tidally locked with its moon Charon—as the moon orbits the dwarf planet, the same sides of both bodies face each other at all times.

The tides—the periodic rising and falling of sea levels on Earth—happen because of the effect of the moon's gravity on Earth as its rotates us. The moon's gravitational pull on the Earth creates a **tidal force** that causes the planet's surface to bulge slightly. The bulge caused by tidal force is evident on the sides of the Earth facing exactly toward and exactly away from the moon at any given time.

MORE MOON

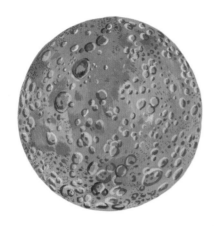

the FAR SIDE of the MOON

Because the moon is tidally locked to the Earth, we never see its far side, sometimes referred to as the "dark side of the moon."

That's a bit of a misnomer, though, because the far side receives just as much sunlight through the course of a month as the near side. It's dark only from our viewpoint; we weren't able to see it until the Soviet space probe *Luna 3* took the first photograph of it in 1959.

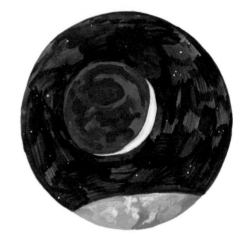

EARTHSHINE

In the days surrounding a new moon, the relative positions of the Earth, moon, and sun sometimes allow for a special phenomenon called earthshine. The moon is in crescent phase directly before and after a new moon, but the part of the moon's face that would normally be dark is softly illuminated by the glow of sunlight bouncing off the Earth onto the moon.

PHENOMENA

DARK SHADOWS

Shadows cast on the moon are extremely dark—much darker than shadows on Earth.

Earth's atmosphere causes light to diffract and spread into shadows, so even though shadows are darker than what's around them, they are never perfectly dark.

Since the moon doesn't have an atmosphere, there's no air to refract light back into shadows, making them appear almost completely black. This was one of the first things American astronaut Neil Armstrong noticed when he stepped out onto the moon for the first time in 1969.

the MOON ILLUSION

When the moon first rises, it often appears larger than it does when it has risen high in the sky. This is the result of the optical "moon illusion." The moon's disk size doesn't actually ever change as it rises and sets—it's always about the same size as a pea held at arm's length. The optical trick happens when we compare the moon with its context at the horizon against its context when it's high in the sky.

LUNAR MARIA
the seas of the Moon

The large, shadowy dark areas that make up the lowlands of the moon are the **lunar maria**. This is Latin for "seas of the moon," a name given by early astronomers who mistook the lowlands for bodies of water. They declared most of them to be seas, one to be an ocean, and the rest lakes, bays, and marshes.

Of course, now we know that the dark areas on the moon are not bodies of water at all. They are basaltic plains, probably formed by lava that once flooded lower, older areas of the moon's surface. The lighter-colored highlands of the moon are heavily cratered from billions of years of bombardment by asteroids and comets. But the names given to the presumed watery geologic features of the moon are still in use today.

Many maria are named after psychic states. It seems we often fear celestial objects as much as we admire them. In a way, it makes perfect sense that some names for lunar maria would be named for aspects of human emotional experiences. We have the Lake of Happiness, but we also have the Lake of Sorrow. We have the Sea of Serenity, but we also have the Marsh of Decay.

HIGHLAND

LOWLAND

LUNAR MARIA (SEAS)
Serpent Sea · Southern Sea ·
Sea That Has Become Known · Sea of Crises ·
Sea of Fecundity · Sea of Cold · Sea of Alexander von Humboldt · Sea of Moisture · Sea of Showers ·
Sea of Cleverness · Sea of Islands · Sea of the Edge · Sea of Muscovy · Sea of Nectar ·
Sea of Clouds · Eastern Sea · Sea of Serenity · Smyth's Sea · Foaming Sea ·
Sea of Tranquility · Sea of Waves · Sea of Vapors · Ocean of Storms

LUNAR PALUDES (MARSHES)
Marsh of Epidemics · Marsh of Decay
Marsh of Sleep

SEA of ALEXANDER
von HUMBOLDT

SEA of COLD

SEA of the EDGE
SEA of WAVES
FOAMING SEA

SERPENT SEA

SEA of WILLIAM
HENRY SMYTH

LAKE of
DREAMS

SEA of
CRISES

SEA of
SERENITY

SEA of
SHOWERS

SEA of
VAPORS

SEA of
TRANQUILITY

OCEAN of STORMS

SEA of
ISLANDS

SEA of
FECUNDITY

SEA of
NECTAR

SEA THAT
HAS BECOME
KNOWN

SEA of
CLOUDS

SOUTHERN
SEA

SEA of
MOISTURE

EASTERN SEA

LUNAR SINUS (BAYS)
Seething Bay · Bay of Love · Bay of Roughness
Bay of Harmony · Bay of Trust · Bay of Honor · Bay of Rainbows
Lunik Bay · Bay of the Center · Bay of Dew · Bay of Success

LUNAR LACUS (LAKES)
Lake of Summer · Lake of Autumn · Lake of Goodness · Lake of Sorrow
Lake of Excellence · Lake of Happiness · Lake of Joy · Lake of Winter · Lake of Forgetfulness
Lake of Softness · Lake of Luxury · Lake of Death · Lake of Dreams
Lake of Hatred · Lake of Perseverance · Lake of Solitude
Lake of Hope · Lake of Time · Lake of Spring
Lake of Fear · Lake of Fear

FULL MOON NAMES

The Algonquin tribes of North America had many names for the full moon at different times of the year.

Colonial American farmers co-opted these names, and farmers and gardeners in North America still use them today to describe the time of year.

When two full moons occur within the same calendar month, the second one is colloquially referred to as a **blue moon**. When two new moons occur within the same calendar month, the second new moon is called a **dark moon**.

January is the Wolf Moon

February is the Snow Moon

March is the Worm Moon

April is the Pink Moon

May is the Flower Moon

June is the Strawberry Moon

July is the Buck Moon

August is the Sturgeon Moon

September is the Corn Moon

October is the Hunter's Moon

November is the Beaver Moon

December is the Cold Moon

THE
SUN

SUNLIGHT is STARLIGHT

For a long time, humans thought our sun was a
different kind of body from the stars they saw in
the night sky. It makes sense; after all, the sun
appears huge in the sky and is so bright that it gives
us our daytime. It's so powerful that we can actually
feel its warmth. But now we know that our sun
is a star like all the others. Sunlight is starlight.
And we have the sun to thank for life on Earth.

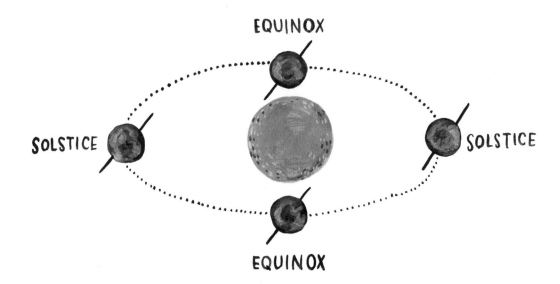

EQUINOX

SOLSTICE

SOLSTICE

EQUINOX

We've noted that the Earth's axis is tilted with respect to its orbit around the sun, and this is why we have seasons. It is winter when our hemisphere receives less of the sun's rays, and summer when we receive more. That's why it's winter in the Northern Hemisphere when it's summer in the Southern Hemisphere, and vice versa.

Twice each year, day and night are approximately the same length everywhere on Earth. These events are referred to as the **equinoxes**, and each hemisphere experiences both a spring equinox—leading into summer—and an autumnal equinox—leading into winter. The word *equinox* comes from the Latin *aequus*, for "equal," and *nox*, for "night."

Also twice each year, the Earth experiences its maximum tilt toward and away from the sun. These events are referred to as the winter and summer **solstices**. The word *solstice* comes from the Latin *sol*, for "sun," and *stice*, for "still," since the sun, having reached either its highest or lowest point in the sky, seems to stand still and then reverse throughout the next quarter of the year, until the next equinox. At the winter solstice, the affected hemisphere receives the least light and the most darkness it does all year (that is, it's the shortest day and the longest night of the year). At the summer solstice, that same hemisphere receives the most light and the least darkness it does all year (that is, it's the longest day and the shortest night of the year).

LUNAR ECLIPSES

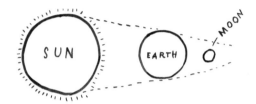

Eclipses occur in the sky when the Earth, moon, and sun are aligned in a perfectly straight line.

A lunar eclipse occurs when the Earth is directly between the sun and moon, and we can see the shadow of the Earth cast upon the moon. A solar eclipse occurs when the moon is directly between the Earth and the sun, and we can see the silhouette of the moon as it travels across the sun.

Because lunar eclipses can occur only when the Earth is between the moon and sun, they happen only during a full moon, and only when the alignment is ideally suited for the Earth to cast a shadow that's visible on the moon. There are usually a few lunar eclipses each year, and they can be seen from anywhere on Earth (as long as it's nighttime when you're watching). The shadow cast by the Earth onto the moon usually has a reddish tint, and never more so than during a total lunar eclipse, which is why those are sometimes called "blood moons."

TYPES OF LUNAR ECLIPSE

PARTIAL ECLIPSE
When the disk of the moon is covered partially by the shadow cast by the Earth

TOTAL ECLIPSE
When the disk of the moon is covered entirely by the shadow cast by the Earth

PENUMBRAL ECLIPSE
When the disk of the moon is covered by the subtler penumbra of the Earth's shadow

SOLAR ECLIPSES

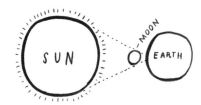

There are usually a few solar eclipses per year, too, but they aren't as easy to see as lunar eclipses.

They're visible only from places along a specific path across the Earth. They also can be dangerous to watch—looking directly at a solar eclipse does, after all, mean looking directly into the sun. If you do decide to watch one, make sure to use the appropriate protective gear for your eyes.

As you might imagine, eclipses were a source of mystery to ancient humans, who believed that the Earth was flat and at the center of the universe. A wide variety of tales were told to explain these eclipses, and like other celestial phenomena, they were sometimes interpreted as bad omens. In ancient Greece, practitioners of witchcraft claimed responsibility for lunar eclipses, boasting their ability to pull the moon out of the sky. In ancient China, solar eclipses were sometimes said to be caused by a dragon taking a bite out of the sun.

TYPES OF SOLAR ECLIPSE

PARTIAL ECLIPSE
When the disk of the sun is partially obscured by the moon

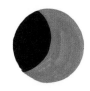

TOTAL ECLIPSE
When the disk of the sun is obscured entirely by the moon, and just a faint rim of the sun's light is visible around the moon

ANNULAR ECLIPSE
When the moon is its farthest from the Earth during a lunar eclipse, its disk doesn't obscure the whole sun, and a ring of the sun is visible around it

the AURORAE

Earth is protected by a magnetic field called the **magnetosphere** that reaches from pole to pole and outward. Also called the **geomagnetic field**, the magnetosphere has a north and a south pole, but they're separate from the geographic north and south poles. And while the geographic north and south poles stay consistent over time, the **geomagnetic poles** move. Currently, the geomagnetic field is tilted about ten degrees away from the Earth's axis.

Our magnetic field is a huge part of what makes life on Earth possible, largely because it shields us from harmful **solar wind**—charged particles streaming outward from the sun into the solar system. Instead of having deadly consequences, solar wind is deflected away from us by the magnetosphere. When solar winds are particularly strong, the disturbances they cause in the Earth's magnetosphere are sometimes visible as **aurorae**.

The aurorae usually occur in and around the geomagnetic poles. The geographic locations where the aurorae are visible have changed over time along with the changing axis of the geomagnetic poles. When the phenomenon of the aurora occurs near the geographic north pole, it is called the **aurora borealis**. Near the geographic south pole, it is called the **aurora australis**.

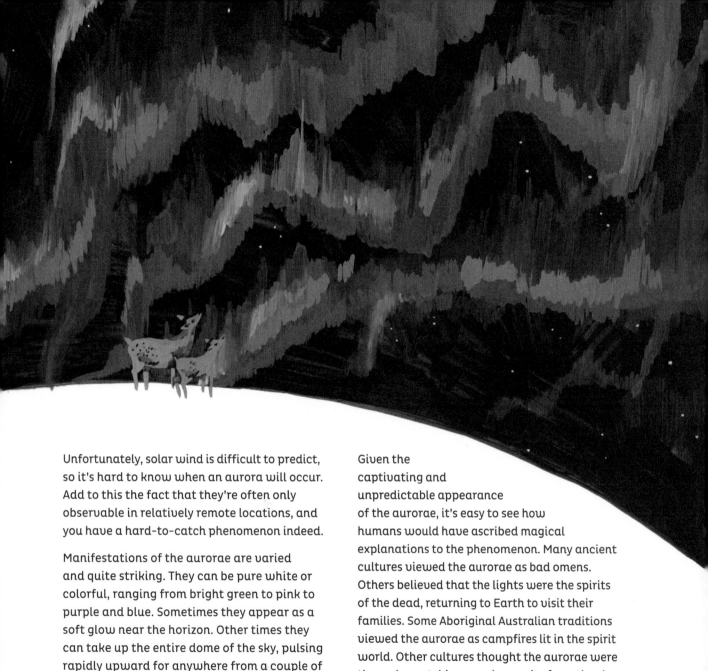

Unfortunately, solar wind is difficult to predict, so it's hard to know when an aurora will occur. Add to this the fact that they're often only observable in relatively remote locations, and you have a hard-to-catch phenomenon indeed.

Manifestations of the aurorae are varied and quite striking. They can be pure white or colorful, ranging from bright green to pink to purple and blue. Sometimes they appear as a soft glow near the horizon. Other times they can take up the entire dome of the sky, pulsing rapidly upward for anywhere from a couple of minutes to several hours at a time.

Given the captivating and unpredictable appearance of the aurorae, it's easy to see how humans would have ascribed magical explanations to the phenomenon. Many ancient cultures viewed the aurorae as bad omens. Others believed that the lights were the spirits of the dead, returning to Earth to visit their families. Some Aboriginal Australian traditions viewed the aurorae as campfires lit in the spirit world. Other cultures thought the aurorae were the gods, watching over humanity from the sky.

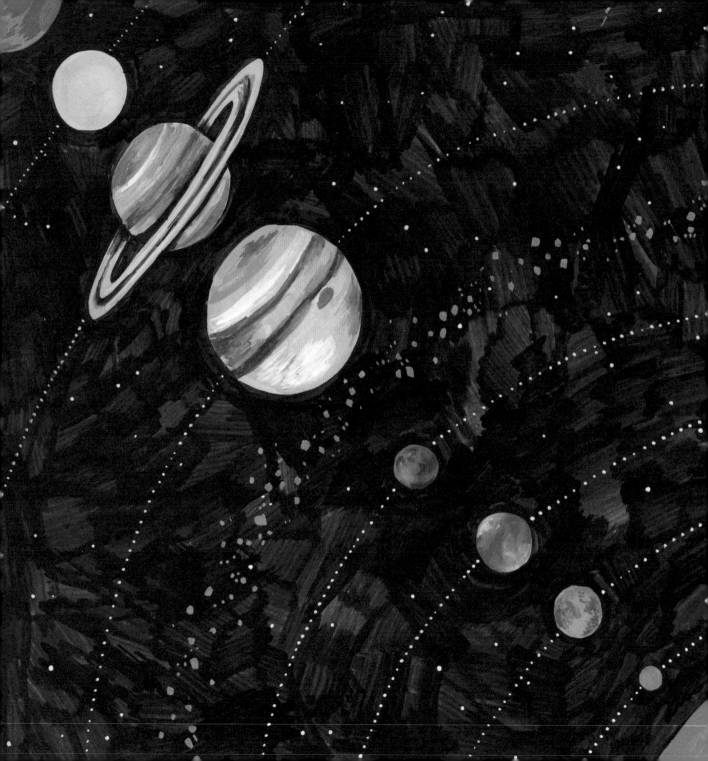

THE PLANETS

"WANDERING STARS"

Early observers of the night sky noticed that not every bright point of light behaved the same way. A few stood out—wanderers that traveled totally different paths across the sky and shone more brightly than the rest of the stars. Some even seem to travel in one direction, then reverse direction, then reverse again and continue their original trajectory.

The ancient Greeks called these misfits *planes aster,* or "wandering stars." From this term, we get the name used for these objects today: *planets*. They travel a unique path across the sky because they're relatively much closer to us, so we perceive their movement differently than we do the movement of the distant stars.

Early astronomers were aware of only five planets: Mercury, Venus, Mars, Jupiter, and Saturn. These are the five planets visible to the naked eye. The two other planets in our solar system, Uranus and Neptune, are visible only with the aid of binoculars or a telescope, and weren't discovered by astronomers until the eighteenth and nineteenth centuries.

In general, the sun's gravity is strongest on the objects that are closer to it, so the solar system's innermost objects have the shortest orbits and the highest **orbital velocities** (they orbit the sun the fastest). Mercury, the planet closest to the sun, takes about 88 Earth days to orbit the sun, compared with the 365 days it takes Earth to complete its orbit. The outermost planet of our solar system, Neptune, takes 165 Earth *years* to orbit the sun—almost 700 times longer than it takes Mercury.

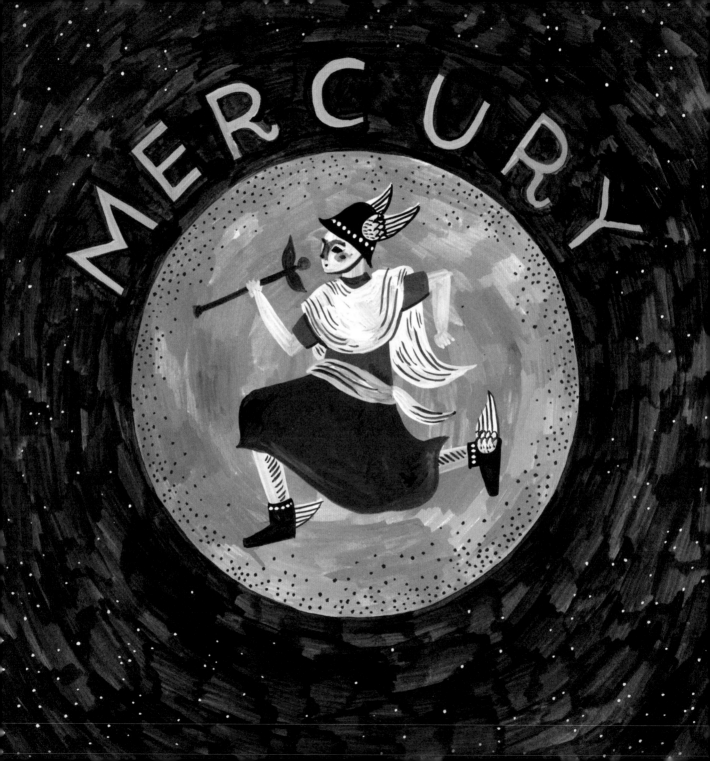

MERCURY

DIAMETER 4879.4 km (3,032 miles)

DISTANCE FROM SUN Due to its eccentric elliptical orbit, the distance ranges
from 47 million km (29 million miles) to 70 million km (43 million miles)

MOONS None

ROTATION PERIOD (LENGTH OF MERCURIAN DAY)
58 Earth days, 15 hours, and 30 minutes

REVOLUTION PERIOD (LENGTH OF MERCURIAN YEAR) 88 Earth days

Mercury is the smallest planet in the solar system and only slightly larger than our own moon. It's the closest planet to the sun, which can make it hard to see in the sky, but it is occasionally visible and has been known to humans since ancient times. Because Mercury travels across the sky faster than the other planets, it was named after the Roman messenger god **Mercurius** who was known for his speed.

The outer planets are composed mostly of gases, but like Earth, Mars, and Venus, Mercury is a **terrestrial** planet, meaning it's composed mostly of rocks and metals. (The word *terrestrial* comes from the Latin name for Earth, *terra*.)

Each planet in our solar system has unique naming conventions for its geological features. On Mercury, craters are named after musicians, painters, writers, and other artists. There's the **Ellington crater**, named after American jazz musician Duke Ellington. There's the **Izquierdo**

crater, named after Mexican painter María Izquierdo. There's even a **Van Gogh crater**, named after legendary impressionist painter Vincent van Gogh.

MERCURY IN RETROGRADE

Because of the phenomenon of apparent **retrograde motion**, Mercury appears to travel along its usual path and then stop and travel backward, before reversing again and traveling onward. Some people believe that the planet Mercury rules communication and truth, and that when it appears to travel backward—when "Mercury is retrograde"—communication and truth are thrown into disarray. The planet never *actually* changes direction—it's just an illusion caused by the relative positions of Earth and Mercury. But if you believe the planets exert influence over the happenings in your life, a planet appearing to change direction several times a year can certainly feel like a bad omen.

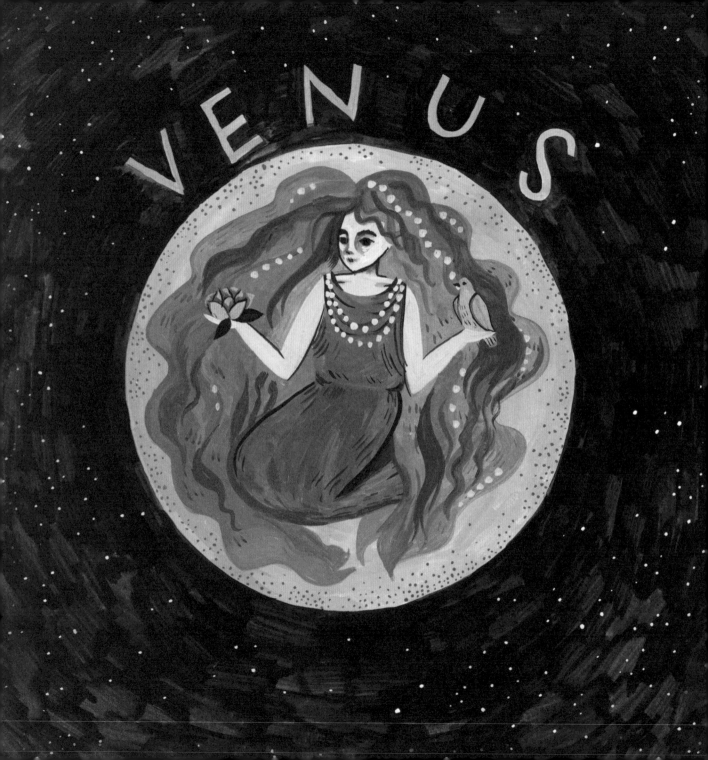

VENUS

DIAMETER 12,104 km (7,520.8 miles)
DISTANCE FROM SUN 108 million km (67,237,910 miles)
MOONS None
ROTATION PERIOD (LENGTH OF VENUTIAN DAY) 243 Earth days
REVOLUTION PERIOD (LENGTH OF VENUTIAN YEAR) 225 Earth days

The second-closest planet to the sun, Venus, is named after the Roman goddess of love and beauty. A couple of odd quirks set it apart from the other planets in our solar system. For example, it spins on its axis from east to west, instead of west to east like the other planets. And it completes a **rotation** on its axis once every 243 Earth days, but completes a **revolution** around the sun once every 225 Earth days, meaning a Venutian day is actually longer than a Venutian year.

Like Mercury, Earth, and Mars, Venus is a **terrestrial** planet. It's similar in size and mass to Earth, but is much hotter. Its heat is not entirely due to its proximity to the sun, but also to a runaway **greenhouse effect** caused by its dense atmosphere, which traps heat. Its average temperature—over 800°Fahrenheit—is hot enough to melt lead, making it our solar system's hottest planet.

It's also very bright—so bright that it can sometimes be seen during the day. The same thick, cloudy atmosphere that makes Venus so hot reflects a huge amount of the sunlight that hits the planet, causing it to shine in our sky.

Most surface features on Venus are named after important women from countries and cultures around the world. Some are named after notable women of history, like the **Tubman crater**, named after American humanitarian Harriet Tubman. Others get their names from female figures from religion and mythology, like the plateau **Lakshmi Planum**, which is named for the Indian goddess of love and war.

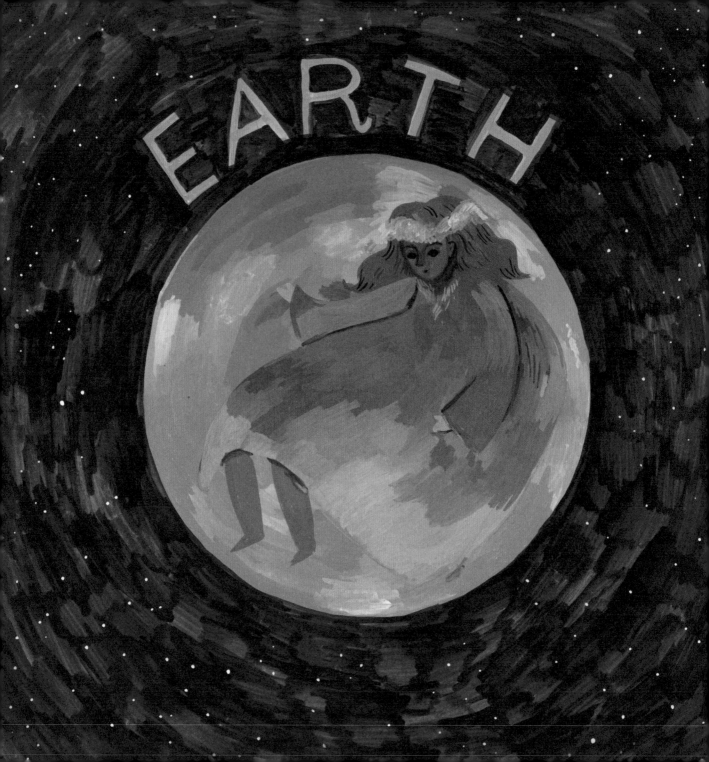

EARTH

DIAMETER 12,742 km (7,917.5 miles)
DISTANCE FROM SUN 149.6 million km (92.96 million miles)
MOONS 1, the moon
ROTATION PERIOD (LENGTH OF EARTH DAY) 1 day
REVOLUTION PERIOD (LENGTH OF EARTH YEAR) 365 days

The only planet that isn't named after a Greek or Roman deity is our very own Earth. The word *earth* comes from Old English, and almost all languages have named the Earth with a word that is the same as or similar to that language's word for "ground." From our perspective on Earth, it doesn't seem like the ground we stand on necessarily has anything in common with the points of bright light passing above us in the sky. It took a long time and some revolutionary scientists such as **Nicolaus Copernicus** and **Galileo Galilei** to show us that the Earth travels around the sun and is a planet like all the others.

Earth is the largest of the four **terrestrial** planets—the planets composed of denser rock and metal with hard outer surfaces. It's the only planet with confirmed **liquid water**, and it's close enough to the sun to feel its warmth, but not so close that it's too hot for life to thrive. Life on Earth is possible only because of the many special circumstances that happened to align for the planet. Even small changes in the planet's position and composition would have made it so that life as we know it would never have been able to exist.

As far as we know, Earth is the only place in the universe able to support life, but we are now searching for other places where life could exist. So far, it seems that Mars is the best candidate—recent missions have revealed that conditions on Mars may once have been much more Earth-like. Saturn's moon **Titan** and Jupiter's moon **Europa** are other candidates in our own solar system thought to have the potential to host life.

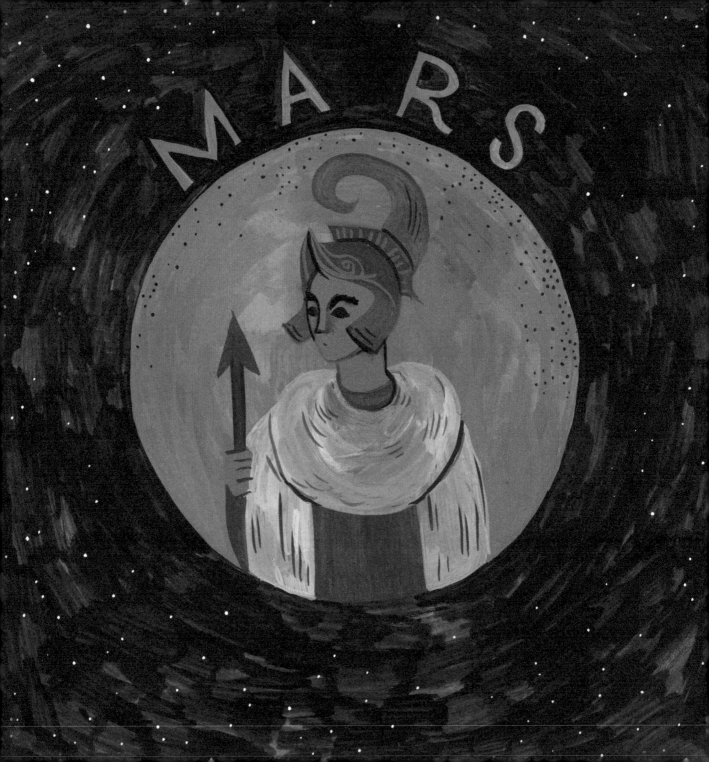

MARS

DIAMETER 6,779 km (4,212 miles)
DISTANCE FROM SUN 227.9 million km (141.6 million miles)
MOONS 2, Phobos and Deimos
ROTATION PERIOD (LENGTH OF MARTIAN DAY) 1 Earth day and 40 minutes
REVOLUTION PERIOD (LENGTH OF MARTIAN YEAR) 687 Earth days

The fourth planet from the sun, Mars, is named after the Roman god of war (analogous to the Greek god **Ares**). In the night sky, Mars often shines red, the color of fire and blood, so the name seems particularly suitable. It's the second-smallest of our solar system's planets; only Mercury is smaller. Despite having only about half the diameter of Earth, Mars actually shares a few key characteristics with our home planet. Its day is almost exactly the same length as an Earth day. Because of its tilted axis, it experiences seasons like we do on Earth. It even has **polar ice caps** like Earth's.

Mars is the final **terrestrial** planet; the planets with orbits beyond it are all gas giants. There's evidence of an atmosphere and **liquid water** in the Martian past, so many scientists believe in the possibility of life—or at least the traces of past life—on Mars.

It is home to **Olympus Mons**, the largest mountain in the solar system. The mountain takes its name from **Mount Olympus**, the tallest mountain in Greece and the mythological home of the Greek gods. It's around two and a half times as tall as Mount Everest.

Mars is a classic setting for science-fiction stories, and fittingly, its larger craters are named after science fiction creators, like the **Roddenberry crater**, named after *Star Trek* creator Gene Roddenberry. Maybe because Mars reminds us so much of home, smaller craters on Mars take their names from places on Earth, like the **La Paz crater**, named for La Paz, Mexico, and the **Reykholt crater**, named for Reykholt, Iceland.

Our connection with the red planet has grown with the **Mars rover** missions that began in 2003. These unprecedented missions use robotic technology to traverse the surface of the planet, searching for signs of water and life, and studying other aspects of Mars.

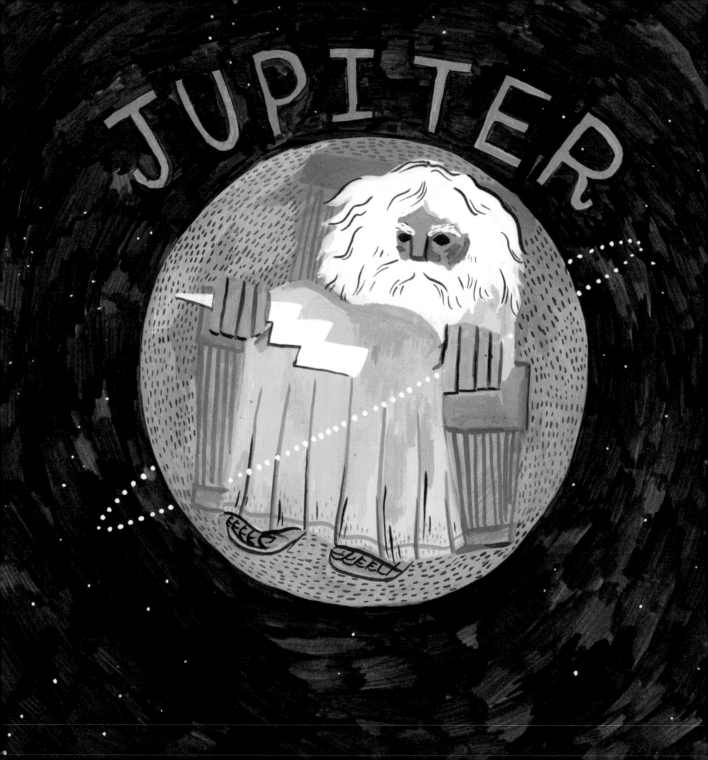

JUPITER

DIAMETER 139,822 km (86,881.4 miles)
DISTANCE FROM SUN 778.5 million km (483.8 million miles)
MOONS 67. Io, Europa, Ganymede, and Callisto are the four largest.
ROTATION PERIOD (LENGTH OF JOVIAN DAY) 9 Earth hours and 56 minutes
REVOLUTION PERIOD (LENGTH OF JOVIAN YEAR) 12 Earth years

Our solar system's fifth and largest planet is named after the Roman god of the sky and thunder, and the king of the Roman pantheon (analogous to the Greek god **Zeus**). It's no surprise that classical astronomers would equate the great **gas giant** with their most powerful god. After Earth's moon and Venus, Jupiter is the third-most-visible object in our night sky—even before scientists discovered its massive size (two and a half times more massive than all the other planets of our solar system combined), it was viewed as an important celestial object.

Jupiter is the innermost and biggest of the gas giants. It doesn't have a solid surface, though it may have a solid core. It's made up of mostly hydrogen and helium gases, and is covered in storms. The biggest of these is called the **Great Red Spot**, a huge hurricane that has been raging in the atmosphere of Jupiter for 186 years or more. The Great Red Spot is bigger than Earth.

Jupiter's day is less than ten hours long, the fastest **rotation** period of our solar system's planets.

Galileo was the first to discover Jupiter's largest moons, now referred to as the **Galilean moons**. These four of Jupiter's sixty-seven moons take their names from figures subjected to Zeus's cruelty: **Callisto**, **Europa**, **Ganymede**, and **Io**. Europa is regarded as one of the most important bodies in our solar system—it's considered a top candidate for scientific exploration and thought to be one of the places where alien life could exist.

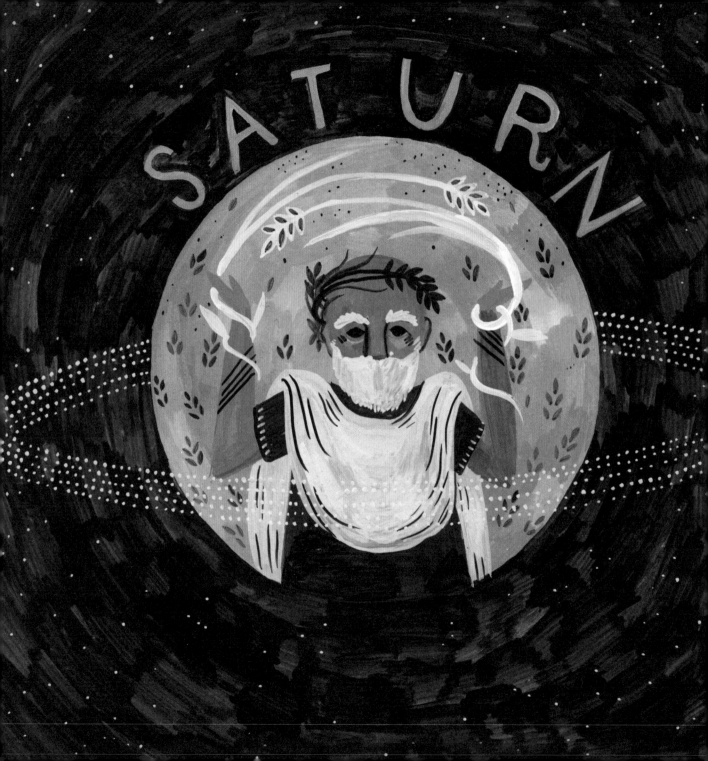

SATURN

DIAMETER 116,464 km (72,367.4 miles)
DISTANCE FROM SUN 1.4 billion km (888.2 million miles)
MOONS 62. Countless additional smaller moonlets and other satellites make up its rings.
ROTATION PERIOD (LENGTH OF SATURNIAN DAY) 10 Earth hours and 42 minutes
REVOLUTION PERIOD (LENGTH OF SATURNIAN YEAR) 29 Earth years

The second **gas giant** and sixth planet from the sun, Saturn is named after the Roman god of agriculture (analogous to the Greek god **Cronus**). **Galileo** was the first to record observations of Saturn's famous rings, but the telescope technology he had was not powerful enough for him to be able to decipher what they were—he thought they could have been moons. In the 1650s, Dutch astronomer and mathematician **Christiaan Huygens** was the first to recognize them as rings. And in the early 1980s, the **Voyager** mission reached Saturn and sent back photos of the rings to Earth.

Saturn's sixty-two moons vary greatly in size. **Titan**, its biggest, is the second-largest moon in the solar system and is larger than the planet Mercury. But some of Saturn's smaller moons are just a few kilometers across and hardly look like our idea of a moon, with shapes more potato-like than spherical. After Titan was discovered in 1655, many of the Saturn's subsequently discovered moons were named after the Titans, the proto-gods and -goddesses of Greek mythology: **Tethys**, **Iapetus**, **Rhea**, and others.

With planets, moons, and other celestial objects beginning to exhaust the well of Greek and Roman deity names, people have finally started including references to other traditions in the naming of celestial discoveries. One group of Saturn's moons takes its names from **Inuit** mythology. These include **Siarnuq**, **Tarqeq**, and **Kiviuk**. Another group is named after figures from **Norse** mythology, including **Skathi**, **Fenrir**, and **Ymir**. A third group takes names from **Gallic** myths, including **Tarvos** and **Albiorix**.

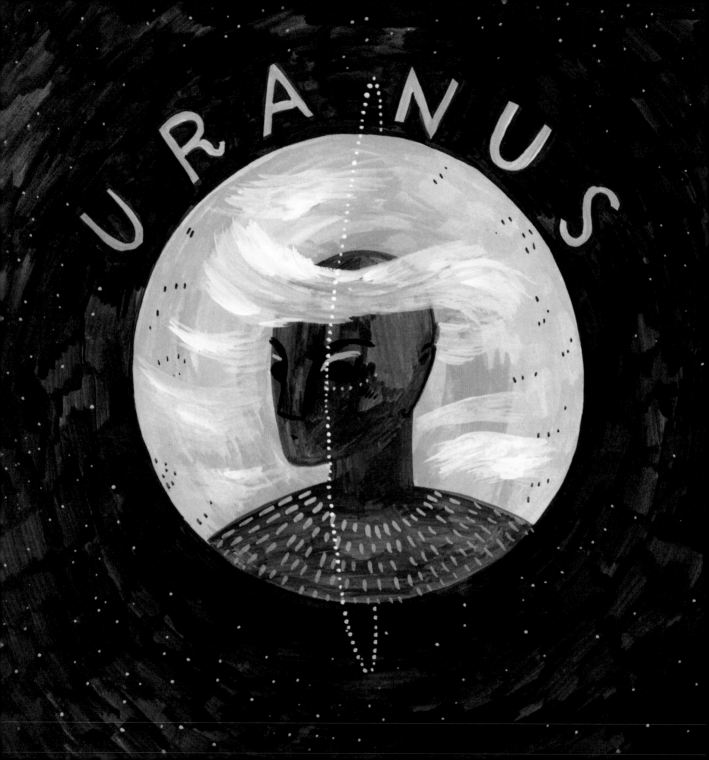

URANUS

DIAMETER 50,724 km (31,518 miles)
DISTANCE FROM SUN 2.9 billion km (1.784 billion miles)
MOONS 27. The five largest are Miranda, Ariel, Umbriel, Titania, and Oberon.
ROTATION PERIOD (LENGTH OF URANIAN DAY) 17 Earth hours and 14 minutes
REVOLUTION PERIOD (LENGTH OF URANIAN YEAR) 84 Earth years

The third **gas giant** and seventh planet from the sun, Uranus is named after the Greek god of the sky, **Ouranos** (known as **Caelus** in Roman mythology), making it the only planet in our solar system named after the Greek iteration of a god rather than the Roman one. Ouranos was Cronus's father and Zeus's grandfather, so in a diagram of the solar system, the three planets Uranus, Saturn (Cronus in Greek mythology), and Jupiter (Zeus in Greek mythology) are arranged like a kind of family tree.

Uranus, along with its outer neighbor Neptune, is classified as both as a gas giant and an **ice giant**, with different chemical composition from the true gas giants Jupiter and Saturn. It appears light blue through a telescope and has a faint ring system, first theorized by **William Herschel** and later confirmed by a **NASA** observatory. And it's the only planet in our solar system with an axis tilted almost perpendicular to its orbit around the sun, so instead of rotating with its equator pointed toward the sun, it points one pole or the other toward the sun at any given time—almost appearing to roll along its orbit like a bowling ball instead of spinning like a globe.

Uranus was the first planet discovered in modern times. Herschel, who observed it in 1781, wanted to name the new planet after King George III, but the naming convention of using figures from classical mythology won out. Scientists who study Uranus today think that the pressure on the planet may be great enough to have created an ocean of liquid diamond underneath the atmosphere of the planet.

Uranus's twenty-seven moons are each named after a character from Shakespearean plays: **Juliet**, **Prospero**, **Desdemona**, and **Puck** are just a few.

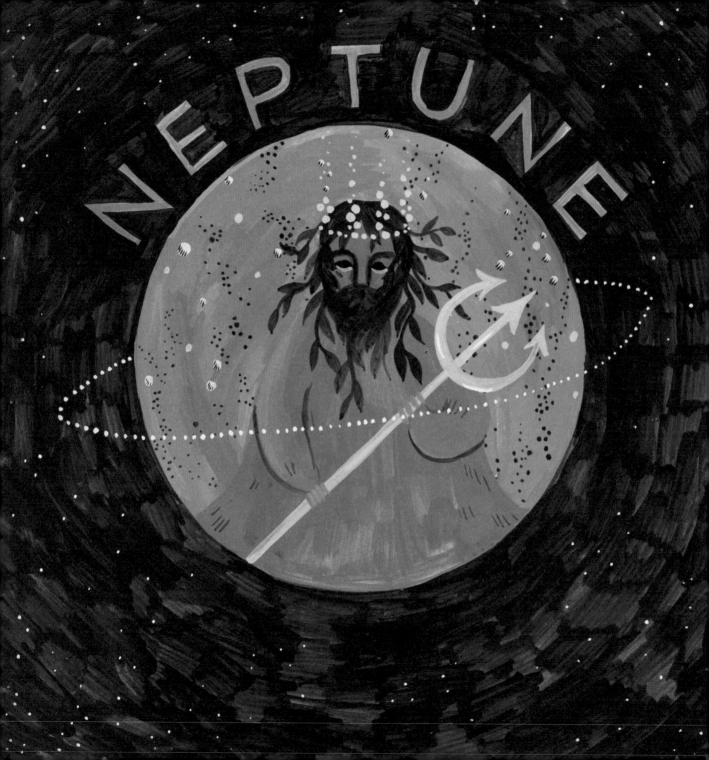

NEPTUNE

DISTANCE FROM SUN 4.5 billion km (2.795 billion miles)

MOONS 14. The largest is Triton.

ROTATION PERIOD (LENGTH OF NEPTUNIAN DAY)
16 Earth hours and 6 minutes

REVOLUTION PERIOD (LENGTH OF NEPTUNIAN YEAR) 165 Earth years

The final **gas giant** and eighth and final planet of our solar system, Neptune, is named after the Roman god of the sea (known as **Poseidon** in Greek mythology). Neptune is similar in size and interior composition to Uranus. When viewed through a telescope, it is an even deeper blue than Uranus, and observations of the planet have revealed its surface to be one of the windiest and stormiest places in the solar system. It even contains visible dark spots—which, like the **Great Red Spot** of Jupiter, are actually gigantic, long-lasting storms.

Neptune's moons are named after minor Greek water gods. Its largest moon, **Triton**, is named after the son of the sea-god Poseidon. Triton is our solar system's only large moon to have a **retrograde orbit** around its planet—its orbit travels opposite to the planet's **rotation**.

Neptune can't be seen without the aid of a telescope, and it is the only planet to have been discovered not by direct observation but by predictions based on mathematical models. Scientists observing the motion of Uranus noticed discrepancies in the planet's position that could be explained only by the influence of another, as-yet-undiscovered planet. This turned out to be Neptune, whose existence was confirmed by telescopic observations soon afterward, in 1846. It has the longest orbital period of any of our planets, making one **revolution** around the sun only every 165 Earth years, meaning it's completed only one full Neptunian year since its discovery.

✳ OUTER OBJECTS ✪

Beyond the outermost planets, there exist countless
bodies that are under the influence of our Sun's
gravity. We're still learning about these bodies—the
idea that there's anything in our solar system outside
the orbit of Neptune is less than a century old.
The objects outside Neptune are, of course, very far
away from us and haven't been studied as much as
our closer planetary neighbors, but more and more
is being learned about them.

the Kuiper Belt

Beyond the orbit of Neptune is a vast ring of
icy bodies called the **Kuiper belt**. It includes
a number of **dwarf planets**, objects similar
to planets but too small to be classified as
such. **Pluto** is one of these. It was considered
a true planet until the early 2000s, when
several additional Kuiper belt objects close
in size to Pluto were discovered and the
concept of a planet needed to be redefined.

Even farther out than the Kuiper belt is a spherical cloud of icy bodies and debris that encircles the solar system. Not much is known about this distant component of our solar system, and it's never been observed directly. It is named the **Oort cloud**, after astrophysicist **Jan Oort**, who first predicted its existence.

the Oort cloud

Some scientists believe that many of our comets originated in the Oort cloud, and even that some objects flung inward from the cloud have been captured as moons by the gravity of outer planets.

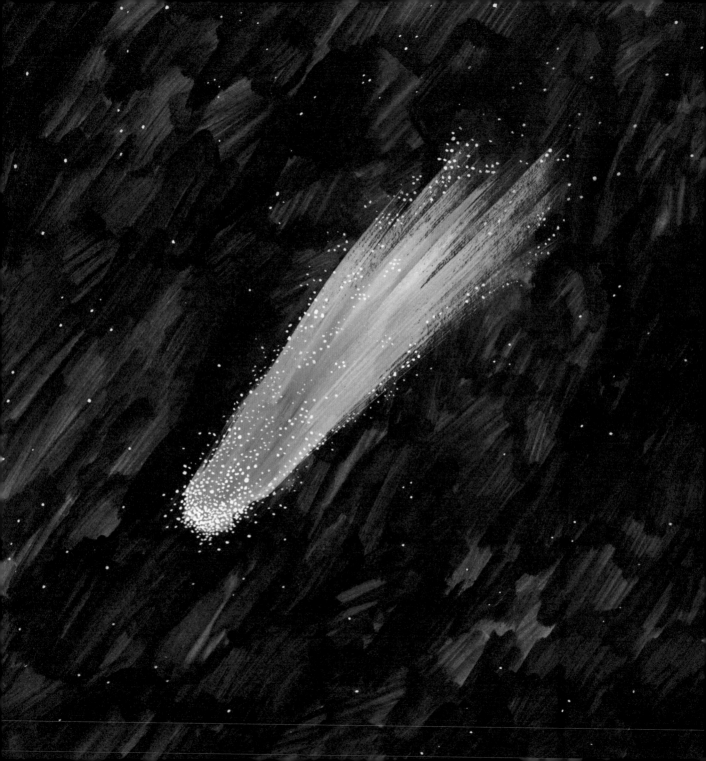

ASTEROIDS, COMETS & METEORS

COMETS

Comets are chunks of rock and ice that travel in elliptical orbits around the sun. They are classified as either **short-period** comets, which take up to two hundred years to orbit the sun, or **long-period** comets, which take longer orbits around the sun—from over two hundred years to up to thousands of years.

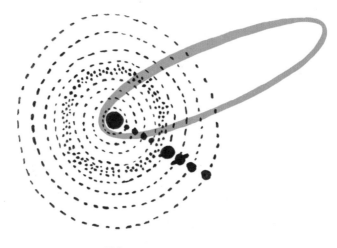

When a comet's trajectory takes it past the sun, it heats up, and the gasses inside it are released, causing a **coma**—a fuzzy atmosphere—to appear around the comet's nucleus. Sometimes this outgassing also causes a **tail** that extends behind the comet. The word *coma* comes from the Greek for "hair"—referring to the hairlike appearance of the coma and tail—and is the origin of the term *comet*.

Before the advent of modern science, comets were often considered ill omens—signals of impending disease and death, an overturning of government, or famine. They were unsettling apparitions in the night sky—they appeared without warning, behaved strangely, and were hard to predict.

Those superstitions had a silver lining: because comets were regarded as important astro-nomical events, they were widely recorded in great detail. These records, dating back many centuries, have helped astronomers study comets of the distant past.

Comets are typically named after the person or people who discovered them. **Comet 35P/Herschel-Rigollet**, for example, was first discovered in 1788 by **Caroline Herschel**, and rediscovered in 1939 by **Roger Rigollet**.

The most widely known comet, **1P/Halley**, is named after renowned scientist **Edmund Halley**. He's a notable exception to the rule of comets being named for their discoverers, because Halley's Comet, as it is also known, had been discovered, rediscovered, and recorded for centuries (the first recorded sighting of the comet was in 240 BCE). But no one until Halley had been able to recognize and prove that those many sightings were of the same comet, reappearing over and over again through the centuries.

METEORS

We sometimes think of the "space" in outer space as empty, but much of it is actually scattered with small pieces of debris. These pieces are not usually harmful to us on Earth. We can even see them when they appear as **shooting stars**.

There are three scientific names for these pieces of debris: *meteoroid*, *meteor*, and *meteorite*. Their names sound similar, but each refers to a distinct stage in the life of one of these pieces of debris that come from the scattered trails of comets and asteroids.

As they travel around the sun, comets often leave a trail of dust in their wake—little chunks of the comet left over when the sun causes the matter around them to **outgas**. These trails can overlap with the orbit of Earth, and with all that space dust floating around our orbit, we eventually run into some of it. When we do, all those little bits of debris come into contact with our atmosphere and burn up all at once, in a dazzling display that we perceive as a **meteor shower.** During a meteor shower, you might see hundreds of "shooting stars" per hour.

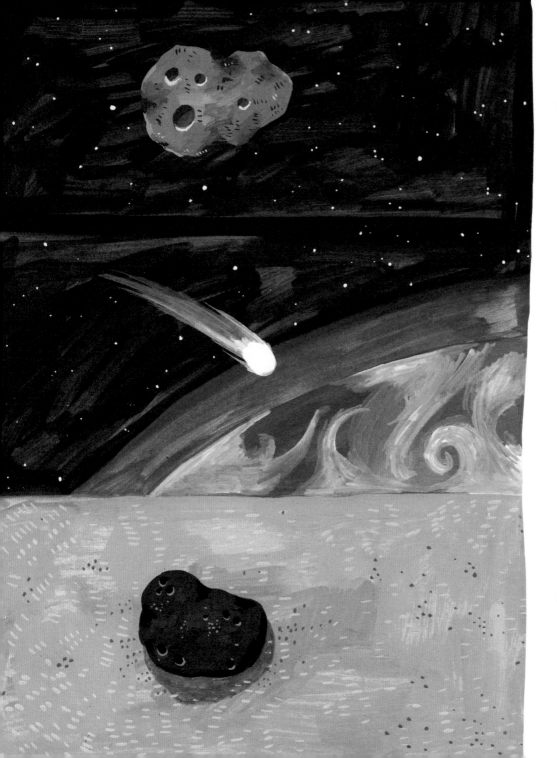

When a small, rocky body is headed toward Earth, it's called a **meteoroid.**

When a meteoroid enters the Earth's atmosphere and burns up, creating a flare or streak of light in the night sky, it is called a **meteor**.

A piece of a meteor that survives its trip through the atmosphere and lands on Earth is called a **meteorite**.

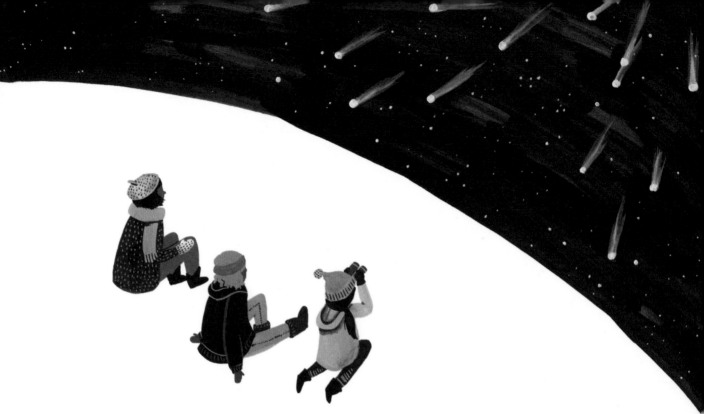

In a meteor shower, meteors appear to shower down from a specific spot in the sky, called the **radiant**, and they are named for the constellation that contains that point. For example, the famous **Perseid** meteor shower occurs each August when Earth passes through a field of meteoroids left behind by the comet **109P/Swift-Tuttle**. The radiant of the resulting meteors is in the constellation Perseus, so we call this meteor shower the Perseids.

Because meteor showers occur when the Earth passes a particular point in its orbit where a lot of debris hangs around, we can track when and where a specific meteor shower will happen—they occur more or less annually.

Meteor showers are easiest to see in the darkest hours of the night, when there is the least amount of light pollution. It's also easier to see them when the moon is new, or nearly new, since a full moon can cause more than enough light pollution to interfere with stargazing. Here are some of the most notable meteor showers.

the QUADRANTIDS

The Quadrantids currently peak in early January. They appear to shower down from the constellation Boötes, but they are named for an obsolete constellation, Quadrans Muralis, whose stars now belong to Boötes.

PARENT COMET **Unknown**

the LYRIDS

The Lyrids currently peak in mid- to late April, and appear to shower down from the constellation Lyra.

PARENT COMET **C/1861 G1 (Thatcher)**

the ETA AQUARIDS

The Eta Aquarids currently peak in early May and appear to shower down from the constellation Aquarius.

PARENT COMET **1P/Halley (Halley's Comet)**

the PERSEIDS

The Perseids currently peak in early to mid-August and appear to shower down from the constellation Perseus.

PARENT COMET **109P/Swift-Tuttle**

the ORIONIDS

The Orionids currently peak in mid- to late October and appear to shower down from the constellation Orion.

PARENT COMET **1P/Halley (Halley's Comet)**

the LEONIDS

The Leonids currently peak in mid- to late November and appear to shower down from the constellation Leo.

PARENT COMET **55P/Tempel-Tuttle**

the GEMINIDS

The Geminids currently peak in mid-December and appear to shower down from the constellation Gemini.

PARENT BODY **Asteroid 3200 Phaethon**

ASTEROIDS

Asteroids are rocky debris in our solar system,
classified separately from comets and meteoroids.
While comets are primarily composed of ice and
dust, asteroids are primarily composed of rock,
like meteoroids, but are much bigger.

The first asteroid to be named, **Ceres**, was discovered between the orbits of Mars and Jupiter in the early nineteenth century. At the time, it was classified as a planet, even though it was only a fraction the size of our moon. As more and more asteroids were discovered, it became clear that Ceres shared an orbit with countless other chunks of rock. It was then reclassified as a dwarf planet, the biggest object in a huge ring of asteroids orbiting the sun. This region is referred to as the **asteroid belt**, and it contains thousands (possibly millions) of individual asteroids.

The term *asteroid* comes from the word *aster*—ancient Greek for "star"—because when asteroids were first being discovered, they looked like bright points of light through the lens of a telescope.

Today, asteroids are often classified as planetoids or minor planets, even though some asteroids are even big enough to have moons of their own. Some are small enough to be confused with meteoroids, and the line between an asteroid and a meteoroid can be blurry—usually the distinction is

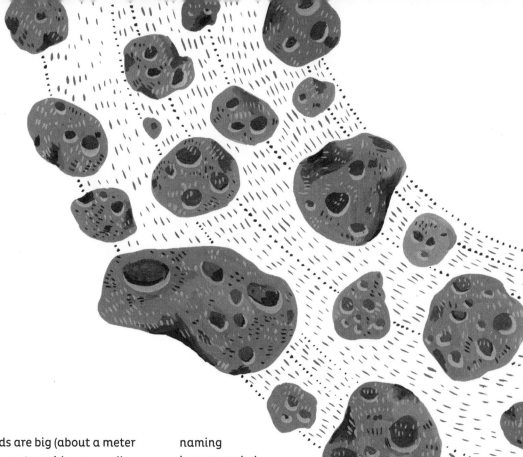

made by size: asteroids are big (about a meter or larger in diameter), meteoroids are small (about a meter or smaller in diameter).

Early on, asteroids were named after characters from Greek and Roman mythology—Ceres was named after the Roman goddess of agriculture. Other asteroids discovered around the same time were given names such as **Juno**, after the queen of the Roman gods, and **Vesta**, the Roman goddess of the hearth and home. Asteroids discovered more recently are named individually by their discoverers, so their naming has expanded beyond the realm of classical mythology. One asteroid discovered in the 1960s is named **2059 Baboquivari**, after a mountain sacred to the Tohono O'ogham nation of the Sonoran Desert of North America, near where the asteroid was sighted. Another asteroid, discovered in the 1980s, is named **2675 Tolkien**, after fantasy author J.R.R. Tolkien.

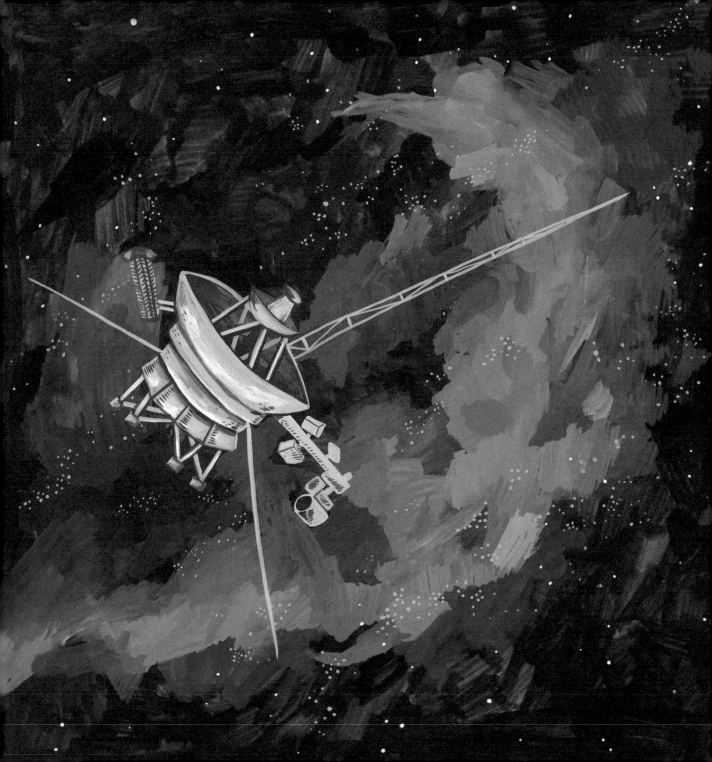

DEEP
SPACE

MESSAGES *for the* STARS

We've spent a lot of time trying to interpret the messages we see in the stars. A few decades ago, we started sending messages back when **Pioneer 10** and **Pioneer 11**, a pair of groundbreaking space exploration missions, were the first to include stories about humanity and life on Earth intended to be read by intelligent extraterrestrial life.

Pioneer 10 was launched from Cape Canaveral, Florida, on March 2, 1972. It made the first direct observation of the planet Jupiter. On June 13, 1983, it became the first spacecraft to leave the solar system. The last contact between Earth and Pioneer 10 was made on January 23, 2003, when the spacecraft's power source finally expired.

Pioneer 11, the sister craft to Pioneer 10, was launched from Cape Canaveral on April 6, 1973. It made the first direct observations of the planet Saturn. The last contact between Earth and Pioneer 11 was made on September 30, 1995.

Both spacecraft will most likely travel uninterrupted on their current trajectories for millions of years before ever coming into contact with stars, because the space in between deep-space objects is so incredibly vast that it's highly unlikely that they will run into anything. Pioneer 10 is headed toward the star **Aldebaran** in the constellation **Taurus**, sixty-eight light-years away. It will take more than two million years to reach it. And Pioneer 11 is headed toward the constellation **Aquila** and will pass by one of the constellation's stars in approximately four million years. Neither will ever return to Earth, but the information they've sent back during their missions has changed our knowledge of space forever.

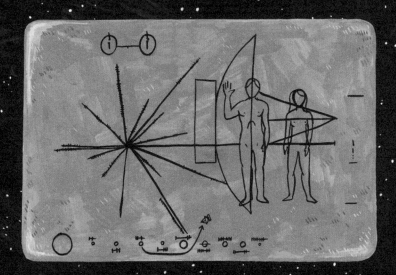

Both Pioneer crafts carry gold-anodized aluminum plaques, engraved with images and symbols. The **plaques** were designed to communicate with intelligent life forms about humans, if the spacecraft were ever to be intercepted on its journey through space.

Artist **Linda Salzman** created the illustrations for the plaque, which included a diagram of our sun's position compared to fourteen pulsars—which could help a hypothetical reader of the plaque triangulate the position of our solar system—and a line drawing of a man and woman, which served as a visual representation of the species responsible for the spacecraft.

VOYAGER INTERSTELLAR MISSION

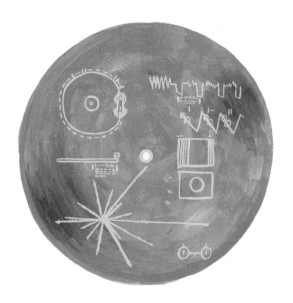

Pioneer 10 and Pioneer 11 were followed by the **Voyager mission**. Voyager 2 was launched on August 20, 1977, and Voyager 1 was launched on September 5, 1977, from Cape Canaveral. Their primary mission was to explore Jupiter, Saturn, and Saturn's largest moon, Titan. Both spacecraft still maintain communications with Earth today.

Expanding on the Pioneer plaque idea, a committee led by cosmologist **Carl Sagan** curated a collection of images and audio that were recorded on gold-plated metal phonograph records and installed on the outside of the Voyager crafts, along with coded instructions on how to play them. The selected images were intended to give a visual overview of life—both human and otherwise—on Earth. They included photographs of planets from our solar system, animals, a human skeleton, a breastfeeding mother, and an illustration of DNA.

The audio recordings on the records begin with people giving greetings and tidings of peace in their respective languages from cultures and places all over the world, including many ancient languages. Then the record plays a selection of sounds from Earth, including thunderstorms, howling dogs, trains, and footsteps. Following these is a curated selection of music from around the world, and finally, an hour-long recording of human brainwaves.

Voyager 1 has traveled farther from Earth than any other humanmade object, and in 2012 it entered **interstellar space**. Voyager 1 and Pioneer 10 are flying in opposite directions away from our solar system and are currently separated by the farthest distance of any two spacecraft. If ever a message from humanity does reach someone or something out in the stars, it really could be one of these crafts.

DEEP SPACE

Dark matter, dark energy, black holes, nebulae, pulsars, quasars. The more we learn about the universe, the more mysterious it seems—and deep space exploration has just begun. We're discovering new galaxies. We're finding exoplanets in distant systems. We're watching the evolution of new stars that help us better understand where and how our own sun was born.

Since the dawn of humankind, we've looked up at the night sky in wonder and awe. But the more we learn, the vaster the cosmos seems. Current science estimates that the universe is tens of billions of light years in diameter—a figure so large it's nearly impossible to fathom.

Humanity has always yearned to learn and explore. Our drive to understand the world around us is part of what makes us who we are. And we're no longer confined to the Earth—we've set foot on the moon, and hope to land on our neighboring planet of Mars next. Our scientific instruments extend our presence exponentially farther, and as science continues to progress, there's no telling what future humans will discover in the deep space that surrounds us.

NEBULAE

Nebulae are vast clouds of dust or gas in interstellar space. They come from dying stars, and they also serve as birthplaces for new stars—they're sometimes called **stellar nurseries**.

Nebulae are extremely vast, but not very dense. They look like clouds from far away because they're so huge, but the density of most nebulae is actually closer to that of a **vacuum** than to the air we breathe on Earth. Depending on what **elements** form a nebula, its color can range from blue, to red, to green—even to colors outside the spectrum of visible light.

Ancient astronomers referred to any blurry or diffuse object in the night sky as a nebula, but they had no way of detecting or imaging the majesty of the clouds we think of as nebulae today. The beauty of nebulae is something we've only become aware of thanks to modern deep space observation by craft like the **Hubble Space Telescope** and other **observation satellites**.

Many nebulae are named for their shapes. The **Horsehead Nebula**, a **dark nebula** in the constellation of Orion first recorded by astronomer Willamina Fleming, is shaped like—you guessed it—the head of a horse. The **Cat's Eye Nebula**, the **Ring Nebula**, and the **Butterfly Nebula** are all named after the familiar objects they resemble.

IS THERE ANYONE OUT THERE?

How likely is it that intelligent life exists outside our solar system? Scientist **Enrico Fermi** famously pointed out the contradiction between two opposing ideas.

On one hand, the probability of Earth-like planets existing throughout the universe is fairly high, and it seems likely that at least some of them should have fostered intelligent life at some point, and, that like us, that life would attempt interstellar travel and communications. On the other hand, there's no evidence that extraterrestrial life has ever contacted or visited Earth. Conditions suggest that extraterrestrial life must exist, yet we have no proof of it. This contradiction is referred to as the **Fermi paradox**.

Even if intelligent life does exist somewhere else in the universe, is it really that likely that it will come across one of the four tiny golden objects belonging to the Pioneer and Voyager missions? Probably not. There's barely a sliver of practical sense in attempting to communicate with potential alien life using small human artifacts like the Pioneer plaques and Voyager records.

But still—why not try? Reading messages from the stars has been an important part of human culture for so long. It's only natural that we'd want to send a message back. And even if we are the only intelligent beings who will ever hear and see these messages, we shouldn't stop sending them. After all, it's our own stories we've been reading in the skies all along.

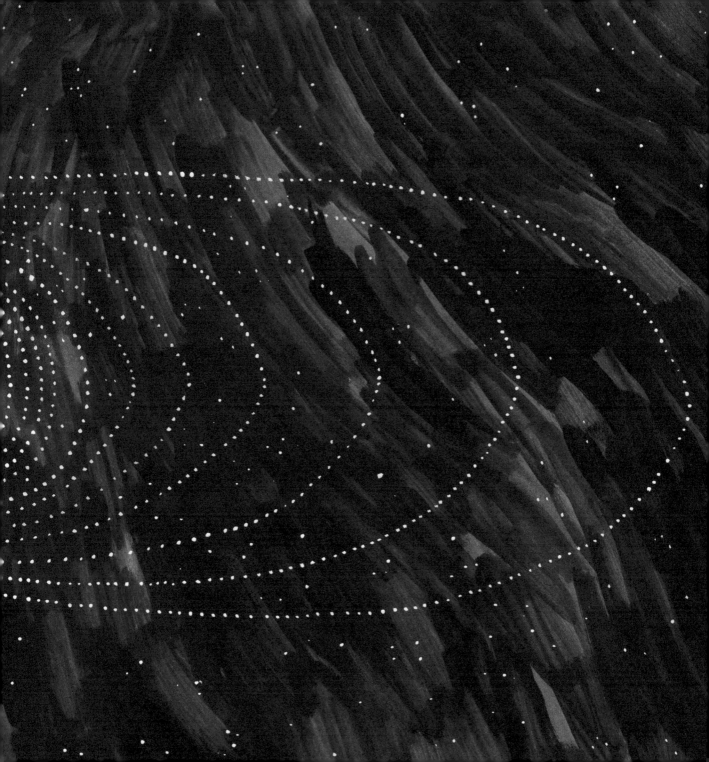

ACKNOWLEDGMENTS

First, I'd like to thank my editor, Kaitlin Ketchum, who has been an expert guide through the creation of this book, and book designer Betsy Stromberg, who keeps it all straight and makes it look beautiful. Thanks also to Jane Chinn, Natalie Mulford, and Windy Dorresteyn at Ten Speed Press.

Thanks also to Julie and Jeff Oseid, my mom and dad, for raising me in and around planetariums, libraries, museums, and gardens; for teaching me to love learning and discovery; and for their love and support.

And finally, thank you to Nick Wojciak, for being a constant sounding board and steadfast best friend.

ABOUT the AUTHOR

Kelsey Oseid is an artist and illustrator based in the Midwest. Her work celebrates science, nature, and the ways humans relate to the natural world. She lives in Minneapolis with her husband, Nick, two cats, and two chickens.

INDEX

Published in the United States by Ten Speed Press, an imprint of the
Crown Publishing Group, a division of Penguin Random House LLC, New York.
www.crownpublishing.com
www.tenspeed.com

Ten Speed Press and the Ten Speed Press colophon are registered trademarks
of Penguin Random House LLC.

Library of Congress Cataloging-in-Publication Data

Names: Oseid, Kelsey.
Title: What we see in the stars : an illustrated tour of the night sky /
 by Kelsey Oseid.
Description: [Berkeley], California : Ten Speed Press, [2017] | Includes
 bibliographical references and index.
Identifiers: LCCN 2017009795 (print) | LCCN 2017012796 (ebook)
Subjects: LCSH: Astronomy—Popular works. | Solar system—Popular works.
Classification: LCC QB44.3 (ebook) | LCC QB44.3 .O64 2017 (print) | DDC
 523.8—dc23
LC record available at https://lccn.loc.gov/2017009795

Hardcover ISBN: 978-0-399-57953-0
eBook ISBN: 978-0-399-57954-7

Printed in China

Design by Betsy Stromberg

10

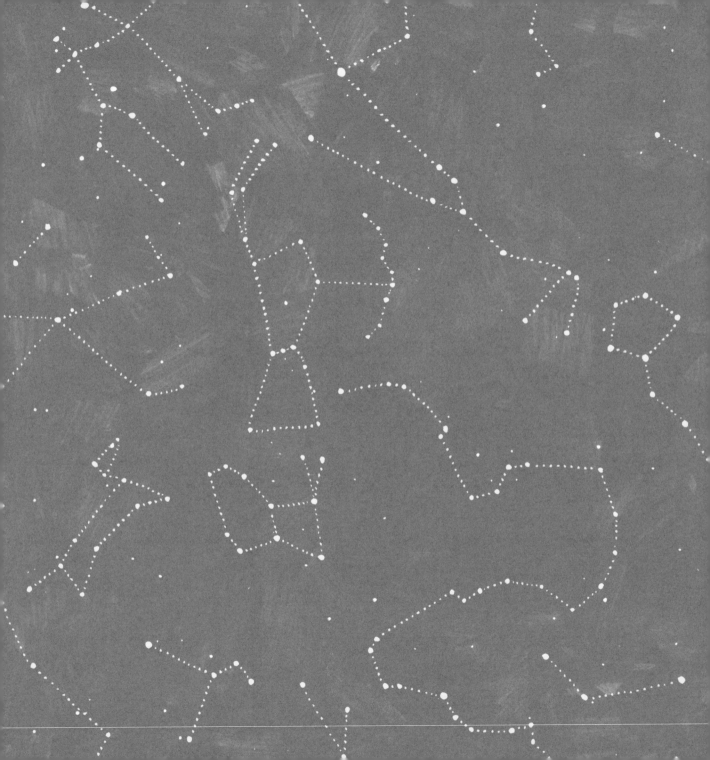